Fresh Ideas
in
Letterhead & Business Card
Design

FRESH IDEAS
IN
LETTERHEAD &
BUSINESS CARD
DESIGN

BY DIANA MARTIN & MARY CROPPER

NORTH LIGHT

CINCINNATI, OHIO

Fresh Ideas in Letterhead and Business Card Design. Copyright © 1993 by North Light Books.
Printed and bound in Malaysia. All rights reserved. No part of this book may be reproduced in any form
or by any electronic or mechanical means including information storage and retrieval systems
without permission in writing from the publisher, except by a reviewer, who may quote brief passages in
a review. Published by North Light Books, an imprint of F&W Publications, Inc., 1507 Dana Avenue,
Cincinnati, Ohio 45207. 1-800-289-0963. First edition.

This hardcover edition of *Fresh Ideas in Letterhead and Business Card Design* features a "self-jacket"
that eliminates the need for a separate dust jacket. It provides sturdy protection for your book while it
saves paper, trees and energy.

97 96 95 94 93 5 4 3 2

Library of Congress Cataloging in Publication Data

Fresh ideas in letterhead and business card design / [edited] by Diana
 Martin and Mary Cropper.
 p. cm.
 Includes index.
 ISBN 0-89134-505-1
 1. Letterheads—Design. 2. Advertising cards—Design.
I. Martin, Diana II. Cropper, Mary
NC 1002.L47F74 1993
741.6—dc20 92-29637
 CIP

The permissions beginning on page 134 constitute an extension of this copyright page.

Edited by Perri Weinberg-Schenker
Design by Carol Buchanan

Dedication

This book is dedicated to Don and Marie Martin, whose
love, support and gentle nudging make all things possible.
And to Evelyn and the late Clarence Cropper, who
believed their daughter could do anything.

Acknowledgments

Our thanks to the many talented designers who sent us
their work for possible selection for this book. Without their
creativity, vision and support, this book would not have been
possible. Our thanks also to the five judges who took on the
difficult task of selecting the best of the best, and to the
book's designer, who has showcased their work.

Contents

Introduction viii

Section 1
The Elements of Letterhead Design 4

A successful letterhead is attractive and enhances
communication. Attention to the elements and process
of letterhead design is the key to that success.

Section 2
Low Budget 12

Great design does not automatically equal expensive design.
Great low-budget design is possible when designers apply
ingenuity and creativity.

Section 3
Type 46

To help communicate a client's image, designers may use
traditional typography, manipulated type, hand-lettering or
even rubber stamps.

Section 4
Visual Effect 76

Color and graphics can communicate instantly and cut
through the clutter of a crowded desk. The right color or an
intriguing visual can say more than words alone.

Section 5
Special Production Techniques 108

Using die cuts, foil stamping, embossing, ghosting,
metallic inks or other special techniques can make the
difference between a good design and a great one.

Permissions 134

List of Clients 135

Index 136

INTRODUCTION

Letterhead design is one of the most exciting yet most difficult types of design to create. You must convey a great deal of information about and a positive image of the client in a relatively small space. You must juggle typography, color, paper, visuals and graphics — often on a very tight budget. Yet few types of design give a designer such a wonderful opportunity to create something truly unique and original.

This book not only showcases some outstanding letterhead designs, but gives you a look at why the solution was chosen and how it was produced. You'll discover why the designer felt this concept was appropriate for the client. You'll discover clever cost-cutting ideas, such as creating type or visuals with rubber stamps and using a split fountain when printing to achieve two-color printing for one-color cost. You'll also see the exciting results that can be achieved by combining embossing and foil on a logo or converting an envelope to get a wonderful bleed.

The 120 letterhead systems and the business cards featured in this book were selected as being the most appropriate, attractive, exciting or innovative designs from all those we received. It was a hard choice because we received so many great designs, but we wanted to showcase those we felt were truly outstanding in some way. Sometimes the beauty lay in a detail: the way the designer used type, the colors or visuals used, or the way embossing or foil was used. Sometimes it was the overall visual effect of the piece, how well it communicated an appropriate image of the client, or how a shoestring budget had inspired rather than hindered creativity.

We hope we've given you plenty of great ideas to inspire you and exciting techniques you'll be able to use in your work. We also hope that you'll enjoy looking at these outstanding designs as much as we have.

THE ELEMENTS OF LETTERHEAD DESIGN

First impressions can make or break a business. An attractive letterhead can turn a client on—or off—in those first few impressionable seconds. As a letterhead designer, you have the power to control the first impression your client makes. The right letterhead design for a client can do more good than the slickest sales pitch or the glitziest P.R. campaign.

What Is Letterhead?

No one will debate that a letterhead's basic function is to act as a vehicle for communication, whether that communication be facts, figures, letters of appreciation or sales pitches. But the majority of professionally designed letterhead systems are also intended as image-creating or business-promoting sales tools. Just as Christian Dior takes great pains to package his perfumes and colognes in only the most sophisticated boxes, a business must take care to present the right image of itself through its letterhead system.

The Make-up of a Letterhead System

Three components make up the basic letterhead system: the letter-writing page, the business card and the envelope. Throughout this book you'll see systems with traditional components but different formats—some bigger or smaller, some folded or turned sideways. You'll see systems with mailing label or labels; with multiple

envelopes; even with multiple letterhead pages. Some systems include blank notecards with matching envelopes, parking passes or videocassette labels.

The basic rule seems to be to apply a letterhead design solution to any printed piece that can be perceived as a selling tool. And why not? Considering the competition most businesses face, it makes sense to take advantage of every possible promotional opportunity.

The letterhead design almost always includes the firm's or organization's name, address and telephone number. But there are many variables—logo, fax number, employee names and titles, list of board members—

whose inclusions often present unique design challenges.

The most successful letterhead system does two things: It communicates the appropriate image for your client through a careful and purposeful use of design and design elements, and it lets the letter fulfill its intention—readability.

Most of the letterhead systems featured in this book,

while functioning as nicely designed marketing tools, yield to the inherent objective of clear communication. Some designers took great pains to design a very pretty "frame" around the writing area on the letterhead page, leaving the center open for a neat business letter.

But not everyone gave clarity the right of way. Some systems, as their designers openly admit (and some even

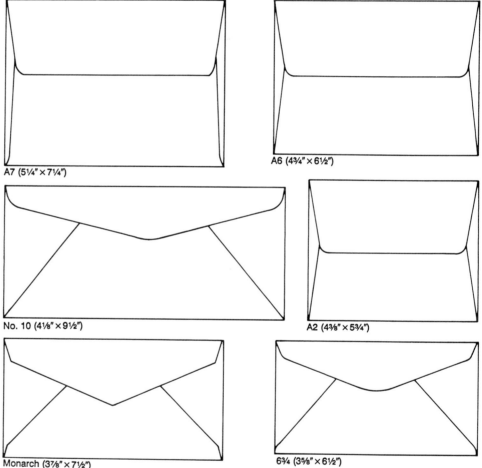

A7 (5¼" × 7¼")

A6 (4¾" × 6½")

No. 10 (4⅛" × 9½")

A2 (4⅜" × 5¾")

Monarch (3⅞" × 7½")

6¾ (3⅝" × 6½")

▲ Envelopes are either stock or converted. Stock envelopes are made and then printed; converted ones are printed then cut and folded. Stock envelopes are less expensive in small quantities and available with little lead time; however, they don't come in all paper grades.

You can have converted envelopes made from any paper, but it generally takes about four weeks. You'll also need to order about 25,000 to make envelope conversion a cost-effective option. The main reason for choosing an envelope conversion, however, is the printing technique to be used. Embossing, thermography and bleeds often do not work as well on stock envelopes.

enthusiastically point out), disregard function in return for visual impact and uniqueness.

Designing for a Client

The first rule for designing a successful letterhead system is *know thy client*. This includes knowing your client's office equipment. Today's almost limitless variations of typewriters, computers and photocopiers will surely influence your design decisions. A dot matrix printer and an ink jet printer produce two very different effects on the same letterhead. The differences in equipment can impact your use of die cuts and embossing, your typeface selection, your choice of paper, as well as myriad other decisions. Be sure to discuss these considerations with your printer.

Beyond familiarizing yourself with your client's office setup, you need to become intimately acquainted with her image or style. Most clients do have an image, but sometimes it won't be defined or refined enough, or your client can't adequately articulate it for you. You may have to help capture it. Your opportunity to do this will be in the design brief, when the client tells you about the project, her business and her needs. Should you find the client reluctant or unable to do so, you need to be prepared to lead this meeting.

One way to prepare for a design brief is to write a list of questions to ask your client. (You should also have a list of questions to ask yourself. Often you can learn a lot about a client just by noting the decor of the reception area, the demeanor of the receptionist, the employees' facial expressions and the areas where money seems to be spent.) The answers to all of your questions will create a personality and a budgetary profile of your client and of her business.

Use the following questions as list starters:

- What do you feel your public image is? What do you want it to be?
- What, if anything, do you like about your existing letterhead design? How well do you think it has worked for you as a selling tool?
- What uses do you plan for your letterhead system? Simple letter writing? A lot of package mailing? (Are labels needed? What size?) Invoicing? (Should the letter-writing area be usable for invoices?)
- How will material be printed on the letterhead components (dot matrix or laser printed, typewritten, handwritten)?
- Who is the typical recipient of the letterhead system? Who do you want to reach?
- Who is going to use the system? Secretaries? Sales reps? Vice presidents?
- Do you have a budget for this job? How firm is it?
- Where do you prefer to spend money—on decor or on equipment?

- What level of risk are you comfortable with? (Does the company prefer to be on the cutting edge, or does it play a conservative wait-and-see brand of business?)

Getting the Best Concept

With the client profile and information gathered at the design brief in hand, the next phase is to develop a concept. Whatever the source of your great idea, always keep in mind your client and the list of specific goals he wants the design to accomplish. Most of the designers whose work appears in this book can explain where they got their ideas, or at the very least what the finished design is intended to communicate. In all honesty, some letterhead design concepts, including many in this book, need explanation. But is this a flaw in the design? Not necessarily. There is no law that says a design concept has to have the immediate comprehension of a billboard. In some cases, the designer's and the client's intention was to intrigue, so a vague concept works.

Where do you begin to look for that just-right solution? Designers often use traditional methods such as word association, where they list words that have a strong, moderate or remote relationship to the client, his image, product or service. Often ideas or images appear or evolve from these words or word combinations.

Many designers wisely use good client ideas that originate during brainstorming sessions or design presentations. The letterhead system on page 65 for Sandesign Homes, Inc. features a client/designer logo collaboration. During a presentation to this client, Toronto designer Ric Riordon, of the Riordon Design Group, presented various logo themes using pillars and gates as design elements. The client agreed with the designer's use of type and illustration combined with an architectural style of graphics, but he had his own idea. He suggested that his home, which was the company's first development, was a suitable motif. The designer agreed. "It was brilliant input from the client, and it worked beautifully," Riordon said.

When you've found the design solution that works for your client, you're in the home stretch. Or at least rounding the bend.

The Elements of Letterhead Design

Whatever design solution you and your client agree on, it will be implemented through the careful and creative use of various design elements. Often the visual or graphic aspect of a solution begins with the designer's sometimes Herculean task of designing the client's logomark.

To be successful, a logo must satisfy many criteria. First it must capture and project an image or picture of

the client. Then it must work well at a small size (often small enough for a business card). It must be readable in a predetermined and restricted area, usually in the left corner of the letter-writing page or envelope. It almost always includes words *and* a graphic, or at least a graphic in the general vicinity of the words. And it has to be designed to work well and look good on any of the system's components. Finally, this tiny design element, some of which are less than one-inch wide, must be clever, one-of-a-kind, memorable and long-lasting. A tall

order for a small element.

Depending on the impression your client needs to create, other graphic elements can be an effective part of the design solution. Consider the childlike stick figures used for the pediatric section of a hospital (see page 87), or the friendly looking dalmatian used for a hot dog restaurant (see page 85).

Another way to communicate an image is through the selection of a typeface. For example, a design for an accountant or lawyer would probably call for a traditional, conservative face, such as Garamond or Berkeley Old

Style. For other, less traditional clients, many designers turn to more modern computer fonts, such as those designed by Emigre Design in Oakland, California. Studios are finding these faces—such as Oblong (see page 49) and Oakland Six (see page 63)—to be particularly suitable for letterhead systems.

Other type solutions can include engraved or foil-stamped type; manipulated type from the computer; hand-lettering, ranging from basic handwriting to slick, three-dimensional and transparent letterforms; low-cost

type, which uses the photocopier for duplication and sizing; press-type for convenience; and rubber stamps for uniqueness, efficiency and versatility.

Color selection is another important element of letterhead design. Your choice must be based both on your client's budget and on the image he needs to convey. One-color printing is not only the most economical; it is often the most appropriate for conservative clients, such as banks and insurance companies. On the other hand, if your client has money for multicolor printing and needs that splash of color to establish himself as creative and progressive, take advantage of the opportunity. Color can achieve a wide range of effects: It can create depth, command attention, organize, divide, intensify or subdue.

Probably the most basic, but sometimes least considered, ingredient in letterhead design is the paper on which it's printed. Today's market offers hundreds of variations suitable for letterhead, and determining which paper will work best with which printing technique is no easy job. The paper's color, its fiber content, its texture, its size and weight and its availability in envelope, cover and business card stock will all play a part in your selection. And for the environmentally conscious, recycled paper now comes in an exciting array of colors and textures.

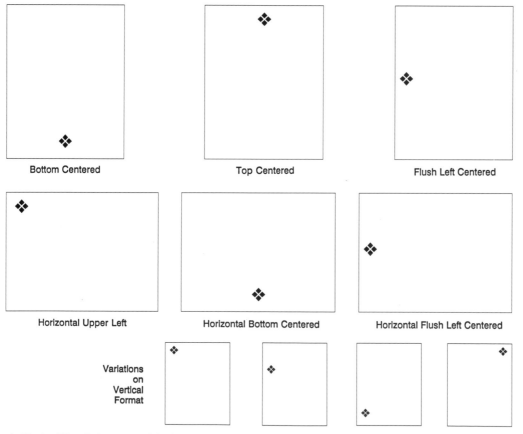

Bottom Centered Top Centered Flush Left Centered

Horizontal Upper Left Horizontal Bottom Centered Horizontal Flush Left Centered

Variations on Vertical Format

▲ **The traditional placement of the logo, company name and address is in the upper-left corner of the sheet, but you can, in fact, put them just about anywhere. Let your design suggest the placement. If you are doing a strongly symmetrical design, placing the information anywhere but the top center of the sheet may throw the design off entirely. However, a design that suggests motion might call for placement in the upper left or even in the upper right. Remember that the paper is to be typed and written on. Don't let your design get in the way of communication unless there is a compelling reason to do so.**

How to Design a Great Low-Budget System

It is possible to design a dynamic letterhead system on a low budget, as many designers have discovered. Pages 12-45 feature thirty-three remarkable systems, all of which were done on a shoestring budget of $2,000 or less. To do this requires ingenuity, flexibility and reliance on your own creative talents. Let's consider these scenarios:

Your client wants a foil-stamped logo, but she doesn't have a foil-stamp budget. You convince her that gold thermography will provide the effect she wants at the price she can afford.

Your client wants an illustrated letterhead, but doesn't want to spend a lot of money. Where do you get low-budget art with little effort? The obvious source is clip art, but that requires your time to find it, modify it, scan it into your computer and produce it camera-ready. Instead, you use rubber stamps, which can be made for as little as five dollars. If you establish a basic layout for the client's letterhead, he can even stamp the letterhead himself.

Your client is your sister, who is starting up a business. She has very limited funds. To minimize your time but maximize your sister's investment, you channel all of your creativity toward one aspect of the design—the visuals—knowing they will have the most impact for your sister's company. Keeping the job

one color and the type simple, you work intensely with a great, local illustrator and end up with an award-winning design.

Trade-offs are another low-budget option that works. Everything can be traded—design, typesetting, printing, paper and illustrations. Printers and paper companies will sometimes sell materials at cost, particularly if you have a positive, long-term relationship with them. You may also get great bargains on paper by using one of your printer's "stock" papers or using extras left from another job.

If you really want to take on a project but the client can't afford your fees, you can negotiate how you get paid. Some designers in this book were paid in hot dogs, beer, compact discs, heating/cooling equipment and decorating services.

Print It Right

As a designer, you have an inherent sense of what looks good, and so designing a pretty piece is probably fun and nearly always successful. Some information is hard to come by, though. How do you use special design or production techniques successfully on a letterhead? When should you use thermography rather than offset printing? When should you use a second color rather than a screen tint? Which paper weights should you use if you plan to emboss or foil stamp?

Horizontal

Vertical

Short Fold Horizontal

"Z" Fold

Short Fold Vertical

Tent Fold

Gate Fold

Book Fold

▲ Business cards can be folded or unfolded. They can have a design or information printed on one side or both sides; the choices are virtually limitless. A business card, however, should be durable and easy to carry. Because cards are handled frequently, they should be printed on a heavy weight of paper, for example, 65# or 80# cover stock. Most business cards measure 3½ x 2 inches, but through folds and die cuts, many kinds of cards may be produced. If the business card will be folded, have it scored on the press to ensure accuracy.

To help you answer such questions and make design decisions, the following pages define and list information on common printing techniques used in letterhead design, including tips for their use and general pros and cons.

The first time you plan to use one of the more complex techniques, discuss your plans in advance with your printer to make sure he can do it, he understands what you want and you spec your project correctly.

Glossary of Letterhead Special Effects

Bleed is when a design element is printed so that a portion of it runs off the edge of the paper. The process requires an extra ⅛-inch along the bleeding edge to allow for gripper space and to ensure the design element bleeds after trimming.

Tip:

- To bleed on an envelope, print the paper stock prior to converting it to envelope format. Bleeding on a pre-folded envelope requires a printer to reconfigure his press, which means extra cost.

Debossing works the opposite of embossing, creating an impression lowered into a paper surface. For tips, please see *embossing.*

Die cut is a special shape that is cut into a printed piece. The process uses hand-tooled or photomechanically-made brass, copper or magnesium dies. The cost of die cutting depends on the complexity of the die. A simple die can cost from $75 to $100; more complex dies can cost hundreds of dollars.

Tips:

- Choose a good quality paper 22# basis weight or higher.
- Avoid delicate or intricate patterns that could tear easily, especially those placed within ¼-inch of the paper's edge.
- Allow leeway for registration between die cuts and printing.

Double bump is to print the same color twice to increase color density. The cost to double bump is equivalent to that of a two-color job.

Dry trap lets you achieve a subtle shading by printing a second color over a first before the latter is dry.

Embossing produces a raised or three-dimensional impression in a paper surface. Commonly used for letterhead logos, graphics or type, embossing can be multilevel, three-dimensional, beveled, sculptured or scorched. During the embossing process, paper is pressed between a female die and a male counterplate. The paper is exposed to pressure and heat to reshape its surface. The most commonly embossed depths range from .012-inch to .024-inch. Blind embossing, which is very popular, has no color or foil added to the raised surface, so it produces a bas relief effect.

Tips:

- Use strong paper with longer fiber formation and heavy basis weight.
- With larger embossing depths, allow plenty of space between design elements for shaping of the paper.
- Plan your design knowing that blind embossing appears smaller once printed.

Engraving is ideal for precise, subtle and high-quality printing, such as fine lines and very small type. The process uses an etched plate and a smooth counterplate on an engraving press. The plate is inked, then wiped dry everywhere except the etched areas. When paper comes into contact with the plate, the ink is transferred to the paper's surface.

Tips:

- Plan your design knowing that the smaller your type or the more intricate your artwork, the less the depth that can be etched.
- Make your engraved areas smaller than 5 x 8 inches, the size of most engraving press plates.
- Letterheads with engraving at top and bottom may require two press runs.
- For best results, use paper with a basis weight of 20-24#.
- Deeper etches can be made on thicker paper.
- Engraving plates are long-lasting and can be used to print envelopes and business cards, thus lowering the overall cost of printing a letterhead system.

Envelope conversion is to print the paper stock prior to trimming and gluing (converting) your envelope. This allows for more innovation in the design, such as the use of wraps, bleeds and embossing.

Foil stamping produces a smooth, opaque area covered with gold, silver, metallic, gloss, matte, clear, color, pearl, wood grain, marble or dusted foils. The process uses a single hot metal die, which applies pressure on a thin ribbon of foil during the press run, transferring an opaque foil material to the paper. Foil stamping is often applied during the embossing process. Applied flat, foil stamping creates a slightly debossed effect. Foil enhancer is a tint film applied to the paper during embossing. This process is known as hot stamping, and variations in the heat used during the stamping create different effects. A foil enhancer makes foil stamping look richer and more legible.

Tips:

- Foils can be stamped over one another.
- The temperature and pressure of the application process can discolor certain color papers, such as browns, yellows and oranges.
- Limits exist for matching foil to Pantone colors.
- Color foils may reproduce darker on certain color paper.
- Plan your design knowing that a flat, color foil stamp appears larger once printed.
- Use strong paper with longer fiber formation.
- Allow plenty of space between design elements to keep foil from spreading across narrow spaces.

Ghosted effect is achieved by overprinting two colors at different percentages.

Tip:

- A light-tone ghosted effect over a dark image is best achieved by printing the darker image first.

Halftone uses a screen to convert continuous tone images into tiny dots.

Tip:

- Many high-quality papers are too porous and uneven to allow nicely reproduced halftones.

Hand-coloring although used infrequently, is a creative, low-cost way to produce a multiple color effect.

Tip:

- Plan and test your choice of paper and medium colors in advance so you'll know how the final effect will look.

Line drawing is any blank image on a white background that's suitable for photographing to make printing plates.

Metallic inks add rich, eye-catching and shiny effects to any design thanks to the aluminum or brass shavings suspended in the ink. The most opaque of all offset inks, metallics can be printed alone or with other inks.

Tips:

- Metallics print best on premium papers with tightly knit surfaces that absorb less ink.
- Linen finish paper shows off metallics well because the paper's texture allows the metallic shavings to dry on the surface.
- If you want a truly reflective surface, consider foil stamping rather than metallic ink.

Offset lithography is a popular printing method that uses a plate with a positive image on its surface. The image area attracts ink and repels water, while the non-image area attracts water and repels ink. The inked image from the plate is offset onto an intermediate blanket, which prints the image on the paper.

Rubber stamps are no longer just for kids. You can custom design your own stamps at a low price and create innovative, one-of-a-kind letterheads. The art on rubber stamps is as good as most commercial illustration and the selection is terrific. (One West Coast store boasts some 200,000 rubber stamps.) Color choices of inks are wide.

Tips:

- Shop around for stamps and pads. You'll find selections in kids' stores, museum shops and even rubber stamp stores.
- Check your local library for *Rubber Stamp Madness*, an industry trade publication. It features ads from dozens of rubber stamp stores and manufacturers.
- Invest in a cheap "how-to-stamp" book and learn basic stamping techniques. You'll also find lots of creative ideas.
- Remember that the art on rubber stamps may be copyrighted, so think before you go stamping crazy.
- Stamps can be custom-made from type, logos or illustrations.

Screen tint produces an evenly toned area of a color. The process breaks solid colors into dot patterns, thus producing lighter values of the original color. Screen tints can create the appearance of increased color at a very low cost.

Tips:

- For letterheads, middle-range tints work best. Screens of 80 percent or more look solid, while screens with 20 percent or less start to lose dots.
- Print on the back of slightly transparent paper to create the effect of screened color on the front of the stock.

Split fountain lets you divide a single ink fountain into sections so you can run more than one color from it and print more colors without increasing the cost; i.e., you can print two colors for the cost of one-color printing.

Thermography creates a raised, rough surface with both a visual effect and a tactile feel. It imitates the look and feel of engraving with less cost and time involved. This process involves the application of a resinous powder to a freshly printed sheet. The powder that doesn't stick to the sheet is vacuumed or shaken off. The sheet is heated at a high temperature, causing the powder to melt and produce a raised surface. Powder can be combined with flat or metallic ink or with tinted or clear varnish.

Tips:

- Thermographed areas can be die cut or bled.
- Type as small as 4 point and fine line illustrations can be thermographed using extra-fine resin.
- Don't use fine line and solid thermography on the same sheet, as the extra-fine resin needed for the detail work may produce an uneven, mottled effect in the solid thermographed areas.
- Use paper with a basis weight of 20# or more.

Varnish is a sealer that overprints ink and paper to protect them from scratching and scuffing. Varnish can be glass, dull or tinted and can be used in small or large areas. Apply varnish to make a design sparkle, give color more brilliance and make photography sharper. Most varnishing is done on sheet-fed offset presses since web printing naturally dies to a glossier film than sheet-fed.

Tips:

- Use gloss varnish to make a surface look smooth and sharp.
- Use dull varnish to make a surface look soft.
- Varnish works best on coated paper.
- If you've never worked with varnish, check with your printer to find out how varnish will work with your paper and design plans.

LOW BUDGET

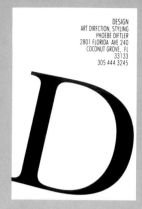

DESIGN
ART DIRECTION, STYLING
PHOEBE DIFTLER
2801 FLORIDA AVE 240
COCONUT GROVE, FL
33133
305 444 3245

Designer/Studio Phoebe Diftler/
Diftler Design
Client/Service Phoebe Diftler,
Coconut Grove, FL/graphic design
Paper Card stock (type unknown)
Colors One, match
Type Times Roman (capital D),
Futura Condensed (remaining copy)
Printing Offset

Concept The large "D" emphasizes
the designer's name and profession.
Special Visual Effect The skewed
"D" and the oversized card format
suggest unusual solutions.
Cost-saving Technique The
mechanical was produced with
camera-ready cards four up.
Budget Minimal **Cost** $15
(printing)

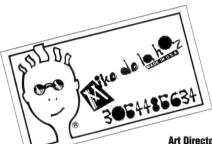

Art Director/Studio D'Ann Rose De
La Hoz/Studio D, Inc.
Illustrator D'Ann Rose De La Hoz
Client Mike de la hoz, Miami, FL/
personal use
Paper Kromekote
Colors One, match
Type Chartpak Pick-up Sticks (cap
M), Oops! (remaining copy)
Printing Thermography

Concept The client wanted a fun,
inexpensive card that portrayed his
personality.
Cost-saving Techniques Press type
was used instead of typesetting, and
the job was gang-printed with
another client's project.
Thermographic printing was more
economical than offset printing.
Budget $100 **Cost** $30 (printing)

Art Directors/Studio Dana Lytle, Kevin Wade/Planet Design Company

Designers/Studio Dana Lytle, Kevin Wade, Tom Jenkins/Planet Design Company

Client/Service Rebholz Photographers, Madison, WI/ photography

Paper Simpson Evergreen

Colors Two, match

Type Futura Bold

Printing Offset

Concept The logo represents those things crucial to a photographer: an eye and a camera shutter. The arrows represent photography's peripheral qualities.

Special Visual Effect A light screen of black is applied vertically to half of the letterhead, envelope and business card, creating a subtle spatial effect and the sense of three colors.

Cost None (design and printing traded for photographic services)

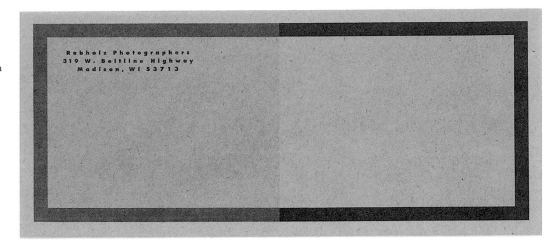

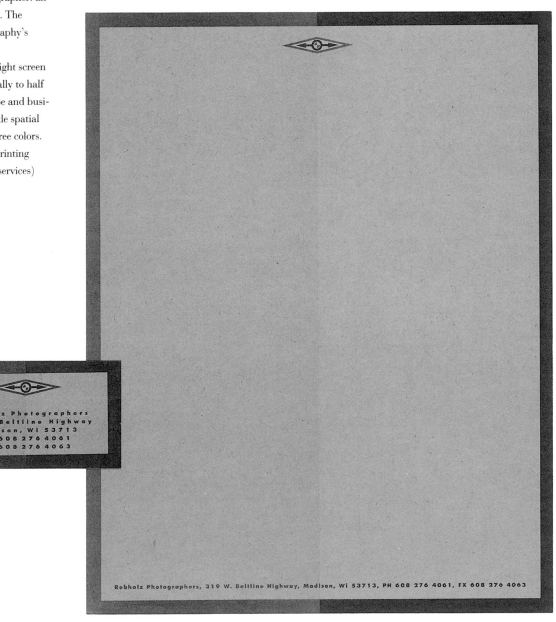

Designer Kathryn Frund
Illustrator Kathryn Frund
Client/Service Carol Chamberlin,
Chamberlin & Devore, Fairfield, CT/
residential landscape architecture
Paper Neenah Classic Crest Millstone
Text and Cover
Colors One per piece, match
Type ITC Garamond Bold
(client/contact names), ITC
Garamond Light Italic (job title),
ITC Garamond Light (remaining
copy)
Printing Offset

Concept The client's specialty in
upscale residential properties is rep-
resented through the use of classical
Renaissance gardens as logo themes.
The design was applied to a multi-
function card, as well as standard let-
terhead components.
Special Visual Effects The logo illus-
trations were created using the
scratchboard technique to add a
formal, elegant feel to the design.
Different logos and colors
add fresh, unex-
pected elements to
each piece.
Budget Minimal
Cost $1,000
(design/printing)

GARUDA
MOUNTAINEERING
5503 17TH NW
SUITE 550
SEATTLE, WA
98107

GARUDA
MOUNTAINEERING
5503 17TH NW
SUITE 550
SEATTLE, WA
98107
206 · 784 · 5186

GARUDA

GARUDA

GARUDA

BYRON C. SHUTZ, JR.
PRESIDENT
GARUDA
MOUNTAINEERING
5503 17TH NW
SUITE 550
SEATTLE, WA
98107
206 · 784 · 5186

GARUDA

Designer/Studio Eric Nord/Ted Mader & Associates
Client/Product Garuda Mountaineering, Seattle, WA/high-end backpacker's tents
Paper French Paper Speckletone Madero Beach
Colors Two, match
Type Helvetica Ultra Compressed (client's name), Univers 57 Condensed (remaining copy)
Printing Offset

Concept The romance and ruggedness of backpacking were important qualities for this letterhead. Because the client was a start-up company, the visuals needed to be especially noticeable.
Special Visual Effects The large, angled visuals are graphically printed as positive and negative shapes and spaces, then screened back for a stark effect. The large type size for the client's name adds to the design's aggressiveness.
Cost-saving Techniques Visuals from a local historical society were photocopied and scanned into a Macintosh for production and output, saving the client the cost of original illustrations and halftones. Type was also computer-generated and lino output.
Cost $500 (design, exclusive of logo), $745 (printing)

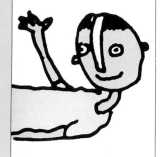

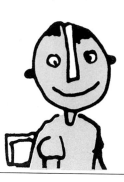

David Butler Illustration 3803 Pennsylvania Kansas City, Mo. 64111 816 - 531 - 3903

David Butler Illustration 3803 Pennsylvania Kansas City, Mo. 64111

My mother calls me David William so by all means, please, call me Dave.

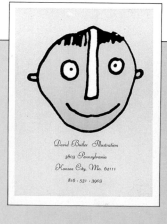

Art Director/Studio David Butler/
River City Studio
Designer David Butler
Illustrator David Butler
Client/Service David Butler
Illustration, Kansas City, MO/
children's illustration
Paper Champion Pageantry Text
White 70#
Colors Three, match
Type Liberty
Printing Offset

Concept The designer uses unusual,
attention-getting, yet appealing
illustrations to create a letterhead
system complete with self-sticking
book plates. He wanted to avoid a
look that was "smug, self-important
or cute."
Special Visual Effects The feeling of
adolescence results from a quirky-
looking character colored in unusu-
al peach and green tones and never
drawn in the same pose twice.
Budget $500 **Cost** None (printing
was donated in exchange for word-
of-mouth credit)

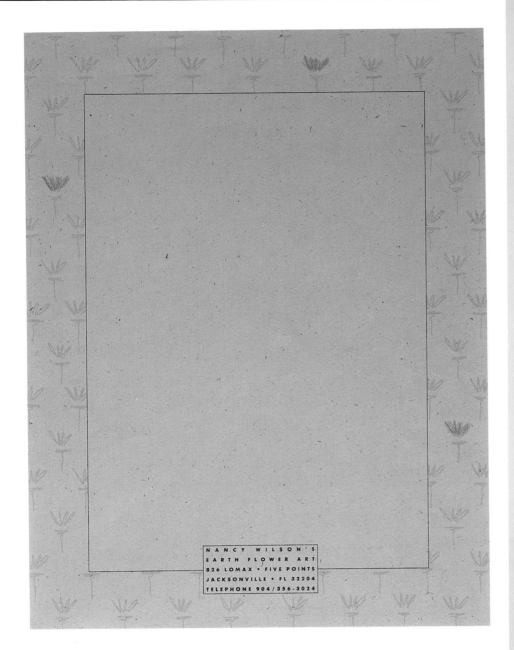

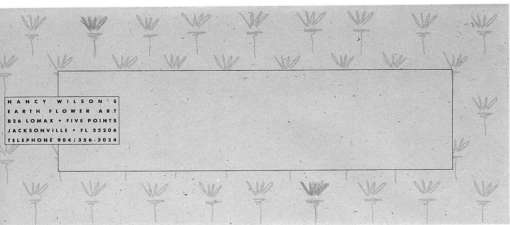

Designer/Studio Tom Nuijens/Robin Shepherd Studios

Illustrator Nancy Wilson

Client/Product Earth Flower Art, Jacksonville, FL/floral art and unusual gifts

Paper French Paper Speckletone

Colors One, match

Type Futura Bold

Printing Offset

Concept This letterhead projects a look that is simple, fun and unusual—adjectives that also describe the client's products. The writing area receives the spotlight, comfortably framed by the screened floral pattern.

Cost-saving Techniques The same one color is printed solid and screened back on two different color papers for a three-color effect. Hand-coloring adds an inexpensive and refreshing four-color touch.

Budget $1,800 **Cost** $1,600 (design/printing)

Designer/Studio Diane Fassino/
Fassino/Design
Client/Service Fassino/Design,
Waltham, MA/graphic design
Paper Strathmore Writing Soft White
Colors One, match/two, opaque
process
Type Futura Condensed (client
name), Adobe Garamond and Adobe
Garamond Expert (remaining copy)
Printing Offset

Concept This studio wanted a dis-
tinctive image that said "design" but,
because of the diversity of its clients,
it wanted to avoid appearing too
trendy or too stylistically limited.
Cost $1,700 (based on a discounted
rate from a printer with whom the
studio often does business)

FASSINO DESIGN

230 Calvary Street Waltham, Massachusetts 02154 617.647.0407 Fax: 647.2646

FASSINO DESIGN

230 Calvary Street Waltham, Mass. 02154
617.647.0407
Fax: 647.2646

DIANE FASSINO
President

FASSINO DESIGN

230 Calvary Street Waltham, Massachusetts 02154
617.647.0407
Fax: 647.2646

FASSINO DESIGN

230 Calvary Street Waltham, Massachusetts 02154

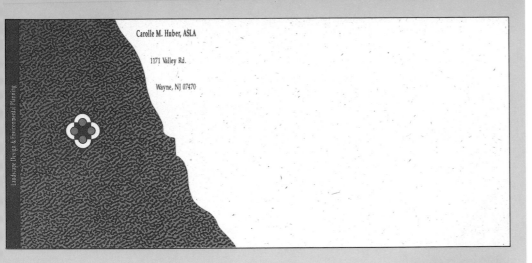

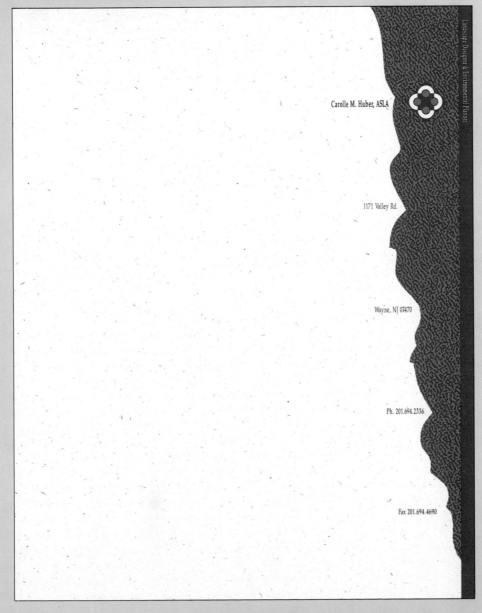

Art Director/Studio Douglas Diedrich/Shooting Star Graphics
Designer/Studio Douglas Diedrich/Shooting Star Graphics
Client/Service Carolle M. Huber, ASLA, Wayne, NJ/landscape design and environmental planning
Paper French Paper Speckletone Madero Beach
Colors Two, match
Type Palatino
Printing Offset

Concept This client, who was breaking out on her own, wanted a look that suggested she was innovative, yet established. The concept was drawn from the business's site development aerial plans; the pattern suggests a site rendering.
Special Visual Effects The color palette depicts the nature of the client's business: trees, plants, bushes and earth.
Cost-saving Technique The pattern was a preprinted adhesive-backed transfer.
Cost $1,500 (design/printing)

P.O.Box 186 · Aromas, Ca 95004

Dale Coke

17245 Tarpey Road
Watsonville, CA 95076
408/726-3100
FAX 408/726-3136

Designer/Studio Melissa McDill/
Another Graphic Design Group
Client/Service Dale Coke, Coke
Farm, Watsonville, CA/organic
farming
Paper Fox River Circa 83 Arctic
White
Colors Two, match
Type Hand-lettering (client name),
Helvetica Condensed (remaining
copy)
Printing Offset

Concept The client wanted a letter-
head design that reflected his low-
key profile yet felt professional. The
designer's solution incorporates a
prominent, classically ruled logo
whose rough-edged lettering and
illustration keep it unpretentious,
and colors that speak of lush fields
and rich earth.
Special Visual Effect The curved
horizon line reflects the client's busi-
ness and adds visual interest to the
stark paper.
Budget $1,500 **Cost** $1,500
(design/printing)

17245 Tarpey Road
Watsonville, CA 95076
408/726-3100 FAX 408/726-3136

FAX 662 9010

1390
S.Dixie
Highway
Suite 2207
Coral Gables
Florida 33146

1390
S.Dixie
Highway
Suite 2207
Coral Gables
Florida 33146

1390
S.Dixie
Highway
Suite 2207
Coral Gables
Florida 33146

Art Director/Studio Silvia Pease/
Pease Design, Inc.
Designer/Studio Silvia Pease/Pease
Design, Inc.
Illustrators George Vallina, Silvia
Pease
Client/Service Pease Design, Inc.,
Coral Gables, FL/graphic design
Paper Neenah Concept Fiber
Glacier Mist Recycled
Colors Two, match
Type Futura Bold Condensed (stu-
dio name), Helvetica Condensed
(remaining copy)
Printing Offset

Concept For a designer with a large
corporate clientele, using a peapod
as a logo was risky. Yet this play on
her name created just the sense of
nature that the designer wanted.
The design was applied to an
invoice, proposal contract and
down-sized, two-sided business
cards, in addition to the standard
letterhead pieces.
Cost-saving Technique Blending the
two colors on press produced a low-
cost shading effect. The gray was
printed first, then the green was run
before the gray ink had dried.
Cost $950 (design/printing)

Art Director/Studio Roy De Young/
Temel West
Designers/Studio Roy De Young,
Janet De Young/Temel West
Client/Service Temel West, Boise,
ID/graphic design
Paper Strathmore Bond Natural
Colors Three, match
Type Memphis Extra Bold (West),
Futura Bold (remaining copy)
Printing Offset

Concept The designer wanted to
create a look that was "active" but
not "overdone." The logo design
suggests his way of looking at things
and questioning why they were done
a certain way and how they are
communicating.
Special Visual Effects The unique
shapes and type placement represent
the designer's way of making com-
mon elements unexpected.
Cost-saving Technique Costs were
kept down by working with a small
family-run print shop and allowing
imperfections in the printing to soft-
en the edges.
Budget $1,000 **Cost** $575
(printing)

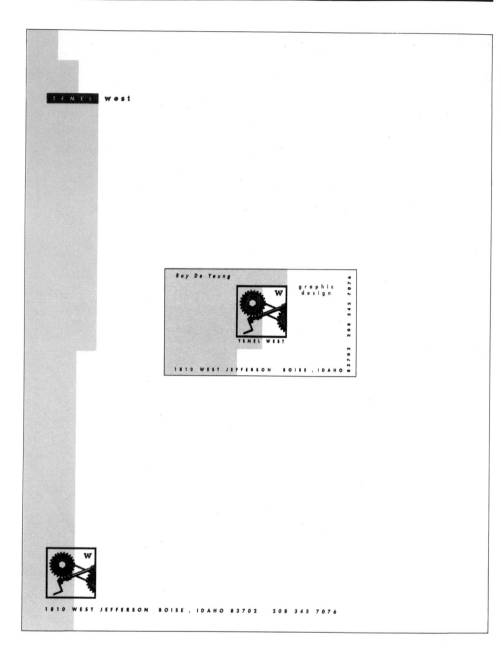

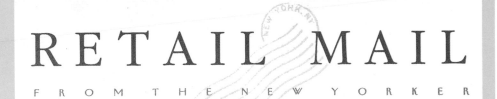

Art Director/Studio Roy De Young/
Temel West
Designer/Studio Roy De Young/
Temel West
Client/Service The New Yorker
Magazine Inc., New York, NY/
publishing
Paper Gilbert Oxford
Colors Two, match
Type Garamond Bold (Retail Mail),
Irvin (remaining copy)
Printing Offset
Irvin Typeface © The New Yorker
Magazine Inc.

Concept The *New Yorker*'s depart-
ments each have individual letter-
heads (used with plain envelopes)
that show their personalities. The
retail mail department needed a let-
terhead design for correspondence
with retail advertisers, merchandise
managers, fashion directors and
buyers.
Special Visual Effect The unique
image of the magazine is seen in the
use of rich, but not bright, colors
and sophisticated paper stock.
Cost $800 (design), $400 (printing)

Designer/Studio Joe Krawczyk/
Krawczyk Design, Inc.

Client/Service Krawczyk Design,
Inc., Orlando, FL/advertising and
graphic design

Paper Beckett Enhance Ultra White

Colors Three, match

Type Bauhaus Demi Condensed and
Manipulated (client name), Friz
Quadrata (client's name screened),
Frontiera 45 (remaining copy)

Printing Offset

Concept The designer's goal was
to create a logo for his studio based
on the letter K, but not so that the
letterform was immediately recog-
nizable.

Special Visual Effect The red and
black color combination is the
designer's trademark; the third color
was kept neutral so as not to detract
from the dominant colors. The
screened background graphic—the
pronunciation of the designer's
unusual name—adds a unique
touch, and a clean, sans serif type-
face promotes easy readability.

Cost $665 (printing)

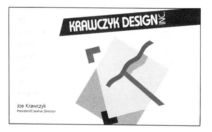

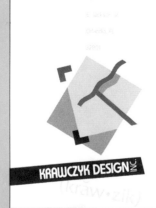

*300 Eighth Street
(Corner of Eighth and Walnut)
Des Moines, Iowa 50309
515/288-0356 • FAX 243-0122*

*Country Club Plaza
4626 JC Nichols Parkway
Kansas City, Missouri 64112
816/756-2027 • FAX 756-3904*

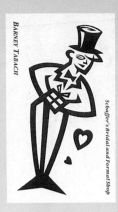

BARNEY TABACH

Schaffer's Bridal and Formal Shop

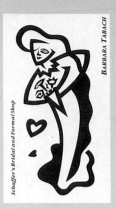

BARBARA TABACH

Schaffer's Bridal and Formal Shop

Designer/Studio John Sayles/Sayles Graphic Design

Illustrator John Sayles

Client/Product Schaffer's Bridal and Formal Shop, Des Moines, IA. Kansas City, MO/formal wear

Paper James River Grafika Parchment White

Colors One, match

Type Hand-lettering (client name in logo), Garamond Italic Bold (remaining copy)

Printing Offset

Concept An updated logo and a more contemporary image were the goals of this client, who had been in business for forty years.

Special Visual Effects Printing 100 percent black ink on the back of the letterhead and inside the envelope produces a screened illusion. Graphics seem almost abstract but are actually wedding bells, flowers, gifts and even portions of the logo itself.

Cost-saving Technique Creative use of a single color kept costs down.

Designer/Studio Melissa McDill/
Another Graphic Design Group
Client/Service Bob Gross
International Travel, Watsonville,
CA/travel-related services
Paper Neenah Classic Crest
Baronial Ivory
Colors Three, match
Type Bookman Condensed (logo),
Gill Sans Book (remaining copy)
Printing Offset

Concept This letterhead uses the
car, boat, train and plane to depict
the spirit of traveling. The images fit
compactly into the stamplike logo
and reappear playfully on the letter-
head components. The illustration
style creates an image of the small,
quaint town in which the client does
business.
Special Visual Effect Although
the illustrations are printed in only
one color, the reversed-out clouds
cleverly create the sense of three
dimensions.
Budget $1,800 **Cost** $1,800
(design/printing)

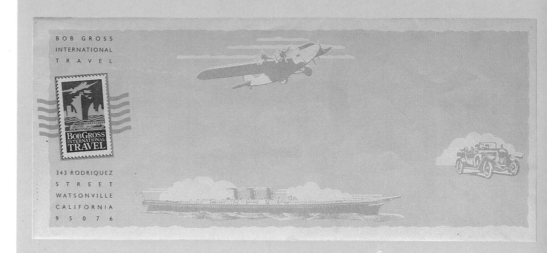

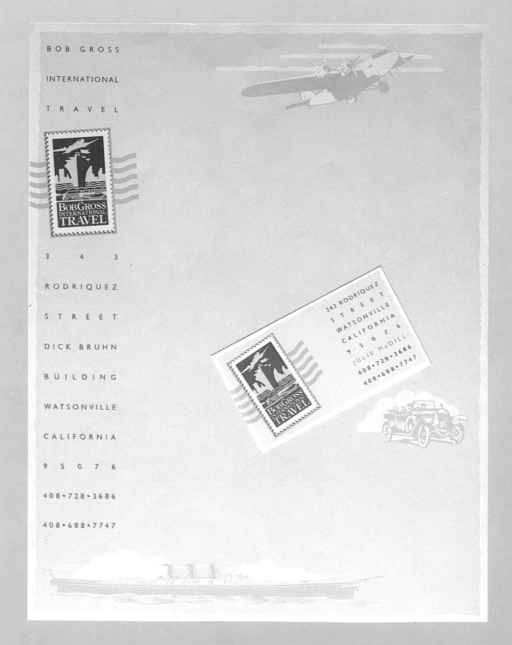

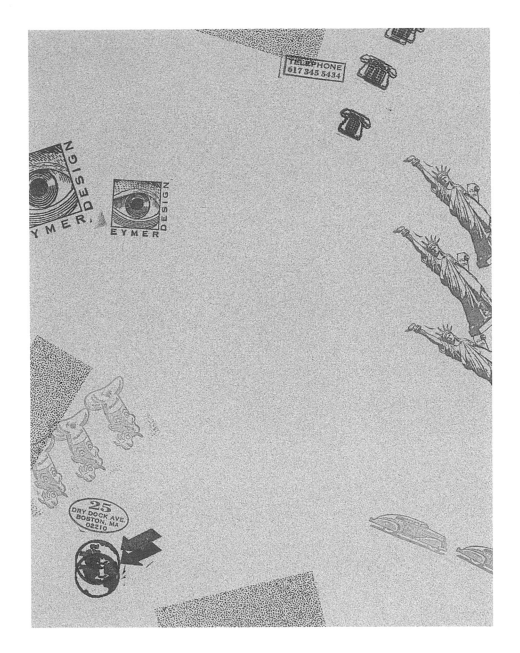

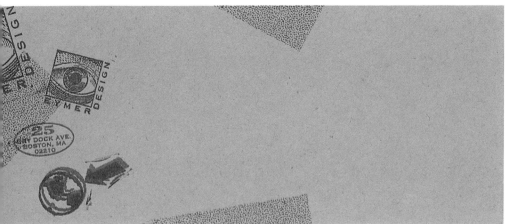

Art Director/Studio Doug Eymer/
Eymer Design
Designers/Studio Doug Eymer,
Selene Eymer/Eymer Design
Illustrator Doug Eymer
Client/Service Eymer Design,
Boston, MA/graphic design
Paper Neenah Classic Linen
Writing Graystone (letterhead),
Simpson Evergreen Kraft (enve-
lope), Simpson Evergreen (business
card)
Colors Five, rubber stamp ink pads
Type Keunstler Script and
Copperplate (logo), Bodoni Slightly
Modified (address), Copperplate
(phone/fax)
Printing Rubber stamps, offset

Concept Rubber stamps are the per-
fect design solution for a letterhead
that needs to be fun, creative and
inexpensive. The system includes a
down-sized two-sided business card
and note paper, as well as standard
letterhead pieces.
Special Visual Effect Different
paper stocks make the system
appear bright and lively, enhancing
the studio's visibility. The names
and logo on the business card were
offset printed.
Cost-saving Technique The stamps,
which cost $5 to $12 each, were
designed on the computer using
scanned clip art and various draw-
ing programs. The stamp maker
often worked from laser copies sup-
plied by the designer.
Budget $500-1,000 **Cost** None
(design services were traded for
paper and printing)

Designer/Studio Romane Cameron/
Studio Seireeni
Client/Service South Schwartz,
Burbank, CA/film production
Paper Chromalux
Colors One, match
Type Poster Bodoni (client name),
Futura Condensed (contact names),
Eurostile (address)
Printing Offset

Concept The designer's version of
Southwest Indian glyphs—an art
form of interest to the client—sug-
gests a woman rising above the tor-
rent. The concept is purposely vague
and open to interpretation while
expressing the client's passion for
creativity and originality.
Special Visual Effects The different
colored stocks for the business cards
make each person the clients work
with feel he or she is getting special
attention. The varied colors also
suggest that no two business rela-
tionships are the same.
Budget $1,500 **Cost** $1,500
(design/printing)

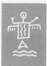

SOUTH · SCHWARTZ

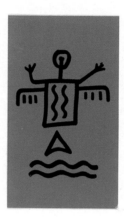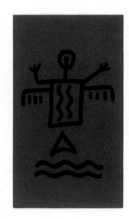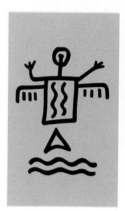

P O B O X 1 0 9 6 9 B U R B A N K C A L I F O R N I A 9 1 5 1 0 - 0 9 6 9
P H O N E 8 1 8 . 7 0 7 . 7 7 6 4 O R 8 1 8 . 9 5 2 . 1 9 7 0 F A X 8 1 8 . 7 0 7 . 3 5 6 9

15 HUTCHINSON STREET WINTHROP, MA 02152

MCFARLAND & MCFARLAND 15 HUTCHINSON STREET WINTHROP, MA 02152 617 846 1116

Designer/Studio Douglas Eymer/
Eymer Design
Client/Service McFarland &
McFarland, Winthrop, MA/copy-
writing and marketing communica-
tions
Paper Neenah Classic Crest Writing
Whitestone
Colors One, process
Type Futura Condensed (client
name), Bodoni (remaining copy)
Printing Offset

Concept The type solution creates a
contemporary yet classical image for
the client.
Cost-saving Technique The use of
one color kept printing costs down.
Budget $1,500 **Cost** $1,500
(design done on trade)

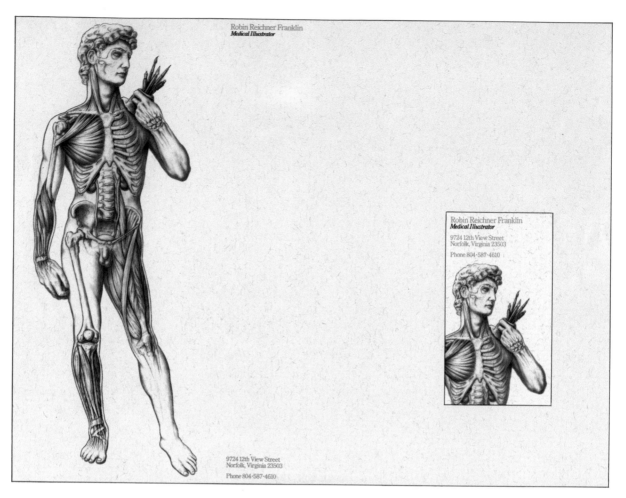

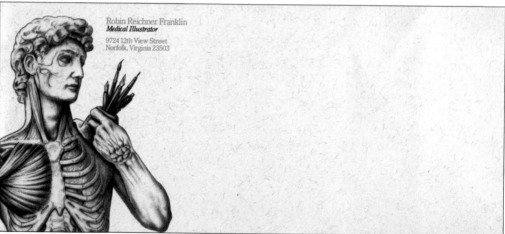

Art Director/Studio Lynn Harrisberger/Harrisberger Creative
Designer/Studio Lynn Harrisberger/Harrisberger Creative
Illustrator Robin Reichner Franklin
Client/Service Robin Reichner Franklin, Norfolk, VA/medical illustration
Paper Fox River Linweave Confetti Sea Mist
Colors Two, match

Type Century Oldstyle
Printing Offset

Concept The letterhead design was planned to be creative and unique, and to demonstrate the client's service. It was imperative to use visuals that show the illustrator's abilities while not being too graphic. The solution was used on a change-of-address card in addition to the stan-

dard letterhead components.

Special Visual Effect The nontraditional and attention-getting layout of the letterhead lets the designer run the illustration as large as possible while still leaving adequate writing space.

Budget $1,250 **Cost** $1,256 (printing; design was traded for illustration work)

REGISTER
PRINTING COMPANY

141 Sinsinawa Ave.
East Dubuque, IL 61025
815 - 747 - 3171
FAX 815 - 747 - 3215

Designer/Studio Roger Scholbrock/
17th St. Design Studios
Client/Service Register Printing
Company, East Dubuque, IL/printer
and service bureau
Paper Fox River Circa 83 White (let-
terhead), Fox River Circa Cove
Green (envelope), Neenah Classic
Crest Granite Cover (business card)
Colors Two, match
Type Adobe Palatino Bold (Register),
Adobe Palatino (remaining copy)
Printing Offset

Concept The logo design incorpo-
rates registration marks, a printing
cylinder and a computer document
icon to show the many facets of the
client's business. Paper and color
combinations vary depending on
available inventory, so the system
demonstrates the client's ability to
successfully mix and match colors
and textures.
Special Visual Effect The diagonal
cut in the letterhead and business
card add unexpected interest.
Cost-saving Technique The client
uses outdated, overstocked or left-
over paper and ink, making the sys-
tem economical and easy to main-
tain.
Budget $2,000 **Cost** None (design
was traded for printing services)

REGISTER
PRINTING COMPANY

141 Sinsinawa Ave.
East Dubuque, IL 61025
815 - 747 - 3171
FAX 815 - 747 - 3215

Tom Werner
Vice President

REGISTER
PRINTING COMPANY

141 Sinsinawa Ave.
East Dubuque, IL 61025

Designers/Studio Kevin Wade, Dana
Lytle, Tom Jenkins/Planet Design
Company
Illustrator Kevin Wade
Client/Service Leslie Barton
Photographer, Sherman Oaks, CA/
photography
Paper Neenah Classic Crest
Whitestone
Colors One, match
Type Futura Heavy
Printing Offset

Concept The logo design is a con-
temporary interpretation of the pho-
tographic process, both mechanical-
ly and creatively. Although the
dashed lines boldly violate the writ-
ing space, their impact is striking.
Cost-saving Technique Screening
the one color and printing on col-
ored stock kept costs low yet created
an expensive look.
Budget $350 **Cost** $350 (printing
only; design was donated)

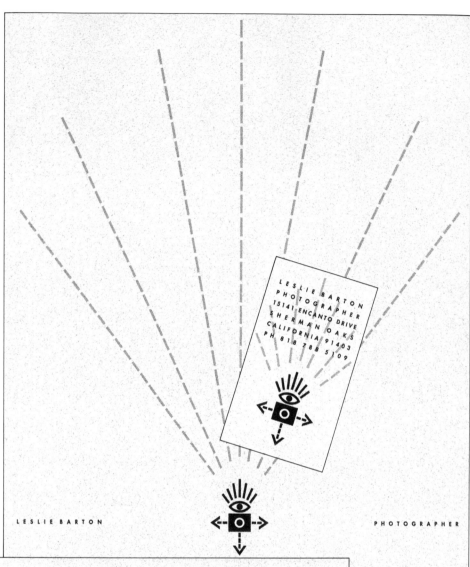

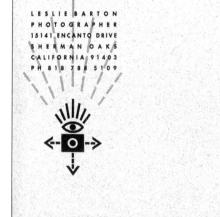

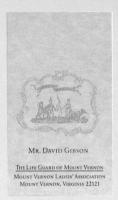

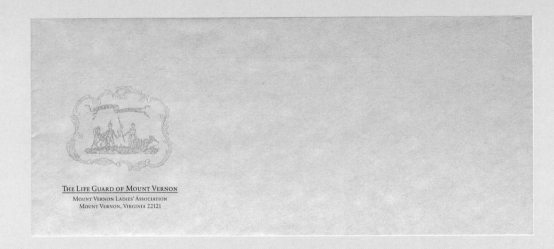

Designer Glenn A. Hennessey
Client/Service Mount Vernon Ladies' Association, Mount Vernon, VA/care and protection of George Washington's home
Paper Hopper Skytone Natural
Colors Two, match
Type Sabon Antiqua Small Caps
Printing Offset

Concept The letterhead's use of an old illustration and parchment paper reflects the nature of the era and of the property being protected.
Special Visual Effect The logo was screened and run across the entire background of the stationery to resemble a watermark.
Cost-saving Technique The graphic was photocopied from an original bookplate in George Washington's collection. The designer reworked the illustration's original type, used in the motto, "Battle or die," to read "Life Guard," the name of the protecting group.
Budget None **Cost** $150 (design rate was reduced for the nonprofit client), $1,152 (printing)

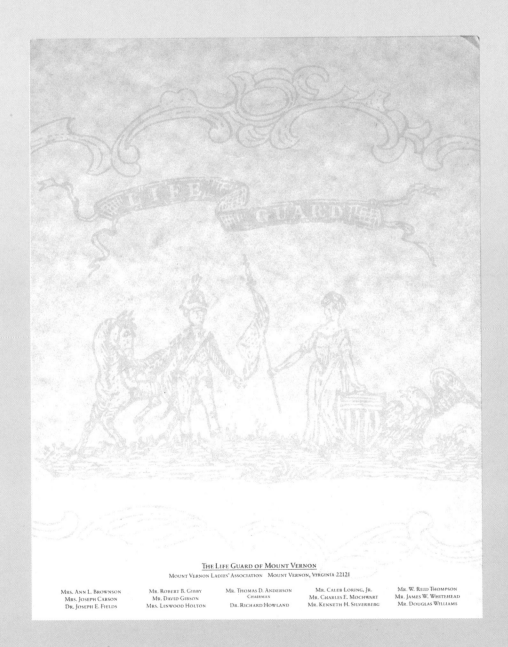

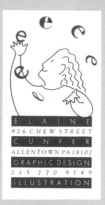

Designer/Studio Elaine Cunfer

Illustrator Elaine Cunfer

Client/Service Elaine Cunfer, Allentown, PA/graphic design and illustration

Paper Strathmore Writing Bright White

Colors One, match

Type Futura Light (client name), Goudy Oldstyle Italic (remaining copy)

Printing Offset

Concept The interplay of type and illustration portrays the artist's dual roles as well as her lighthearted nature.

Cost-saving Techniques As a graduate student with few resources, the artist kept costs minimal by doing the design, illustration, typesetting, stats and mechanicals herself. She also bought paper at an outlet and found a good, budget-conscious printer.

Budget None **Cost** $150 (paper/printing)

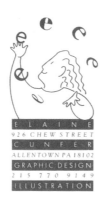

ⅢARTIN ▼ILLARREAL
GRAPHIC DESIGNER
21 PLANTATION DRIVE
ATLANTA , GA 30324

ⅢARTIN ▼ILLARREAL
GRAPHIC DESIGNER
21 PLANTATION DRIVE
ATLANTA , GA 30324
[404] 365-9811

ⅢARTIN ▼ILLARREAL
GRAPHIC DESIGNER
21 PLANTATION DRIVE
ATLANTA , GA 30324
[404] 365-9811

Designer/Studio Martin Villarreal/
The Real Image, Inc.
Client/Service Martin Villarreal,
Atlanta, GA/graphic design
Paper Neenah Classic Crest Avon
Brilliant White
Colors Two, process
Type Univers
Printing Offset

Concept The intricate marriage of
the pencil—a traditional design
tool—and the designer's initials
represent his profession and his
identity.
Special Visual Effects The three
vertical lines that comprise the "M"
in the designer's name are a formal
representation of his signature. The
flourescent orange spots focus
attention, and the rich blue reflects
the designer's bold style.
Budget $700 **Cost** $575 (printing)

Art Director/Studio Lynn Harris-
berger/Harrisberger Creative
Designer/Studio Lynn
Harrisberger/Harrisberger Creative
Illustrator Lynn Harrisberger
Client/Service Harrisberger
Creative, Virginia Beach, VA/
graphic design
Paper Fox River Linweave Confetti
Ice
Colors Four, match
Type Hand-lettering (client name),
Eldorado (remaining copy)
Printing Offset

Concept The southwestern theme
was chosen because the designer is
originally from Texas and wanted to
bring some of that flavor east. The
theme sets her apart from other stu-
dios because it is an unexpected
visual in Virginia.
Special Visual Effects Although this
color palette is typically
Southwestern, the colors are more
subtle than usual, creating a softer
air of sophistication.
Budget None **Cost** $876 (materials
only; design services were traded for
printing)

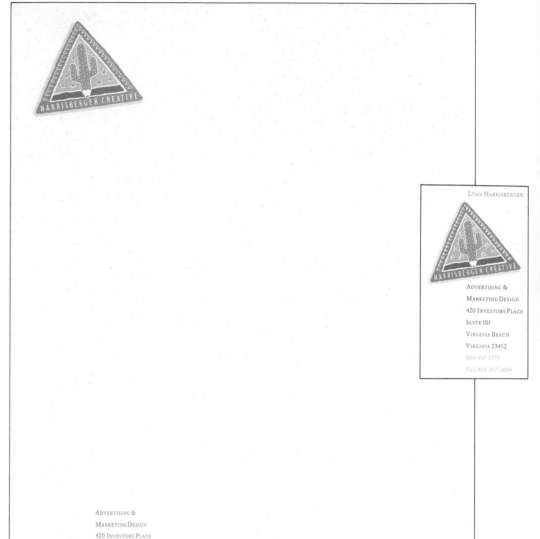

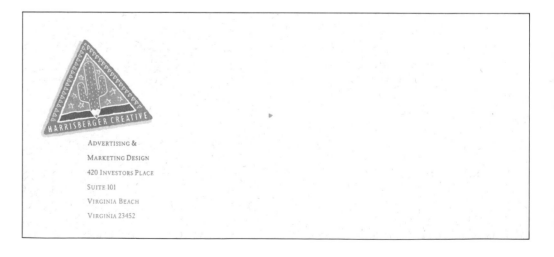

Sea Frontiers®

THE MAGAZINE OF THE INTERNATIONAL OCEANOGRAPHIC FOUNDATION/UNIVERSITY OF MIAMI
4600 RICKENBACKER CAUSEWAY • MIAMI, FLORIDA 33149 • 305-361-4888 • FAX: 305-361-4711

Sea Frontiers®

THE MAGAZINE OF THE INTERNATIONAL OCEANOGRAPHIC FOUNDATION/UNIVERSITY OF MIAMI
4600 RICKENBACKER CAUSEWAY•MIAMI,FLORIDA 33149•305·361·4888•FAX:305·361· 4711

Art Director Phoebe Diftler/Sea Frontiers magazine, University of Miami

Client/Service Sea Frontiers magazine, Miami, FL/environment-oriented oceanographic magazine

Paper Recycled Environment 24#

Colors Two, match

Type Helvetica Compressed (client name), Futura Book (remaining copy)

Printing Offset

Concept This design reinforces the magazine's 1991 redesign, which created a vibrant, sporty and scientific image. The letterhead uses the new logo to create a dynamic, modern design.

Special Visual Effect Using a second blue tone for "Sea" spotlights the magazine's editorial focus.

Budget Minimal **Cost** $300 (printing)

Designer/Studio Ellen Cohen/Ellen Cohen Design

Client/Service John F. Goodman, Washington, D.C./spoken, written and visual communications

Paper Neenah Classic Crest

Colors Two, match

Type Goudy Oldstyle

Printing Offset

Concept Visual representation of the client's diverse services was achieved through the use of thematic line illustrations.

Special Visual Effect The muted green and gray colors were chosen for their distinctive yet corporate image.

Cost-saving Technique Low-cost clip art illustrations were tightly cropped, photocopied and touched up, then printed green on gray for impact.

Budget None **Cost** $700 (printing)

ELM AT 17TH
P.O. BOX 855
DUBUQUE, IA
52004 - 0855
319.556.5147
FAX NUMBER
319.556.0648

Designer/Studio Roger Scholbrock/
17th St. Design Studios
Client/Service 17th St. Design
Studios, Dubuque, IA/graphic design
Paper French Paper Speckletone
Cream
Colors Two, match
Type Garamond Bold (logo), Futura
Heavy (remaining copy)
Printing Offset

Concept Different colors and hand-
illustrations on each of these letter-
head components communicate the
studio's computer and traditional
approaches to design.

Special Visual Effects The logo uses
steel and wood cut engravings to
capture the character of the studio's
facilities, a circa 1903 factory. Three
bright, sophisticated color combina-
tions with one common color reflect
a modern palette but still feel turn-
of-the-century. Charcoal gray, rather
than black, was chosen because the
former has an attitude of sophistica-
tion and a degree of depth that black
doesn't.

Special Production Technique The
charcoal gray was double-bumped to
increase its density and add richness
and depth to the color, making this a
three-color job.

Budget $1,000 **Cost** $467 (print-
ing)

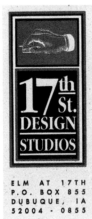

ELM AT 17TH
P.O. BOX 855
DUBUQUE, IA
52004 - 0855

Art Director Jon E. Dilley

Designer Jon E. Dilley

Illustrator Jon E. Dilley

Client/Service Dilley Illustration &
Design, Kansas City, MO/
illustration and graphic design

Paper Neenah Classic Laid
Ivorystone (letterhead), junk
(business card), Brown Kraft
industrial grade (business envelopes)

Colors Two, match

Type Hand-lettering (client name),
Century Schoolbook (remaining
copy)

Printing Offset

Concept This unique design solution
emphasizes creativity in the face of a
very low budget. The design was
applied to an invoice and a 4 ⅝ x 6
¾-inch business envelope, as well as
standard letterhead components.

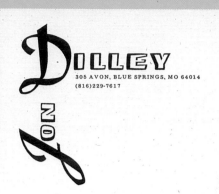

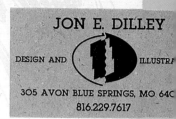

Special Visual Effects
Envelope stickers with
the designer's illustrations
add freshness. These same
visuals, printed in metallic
ink on the letterhead and
invoice, are screened back to keep
pen ink from beading.

Cost-saving Techniques The business
card uses "junk" stock originally
from inside boxes of rubylith. The
18 x 24-inch sheets were cut down
for printing. The designer printed
the job himself at the family business.

Budget $200 **Cost** $160 (printing)

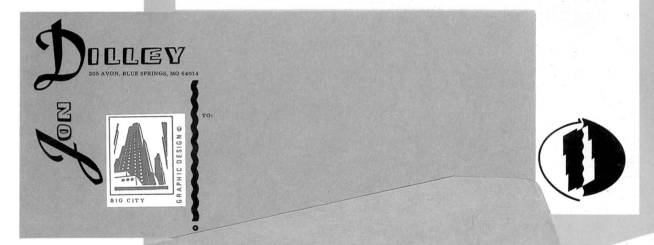

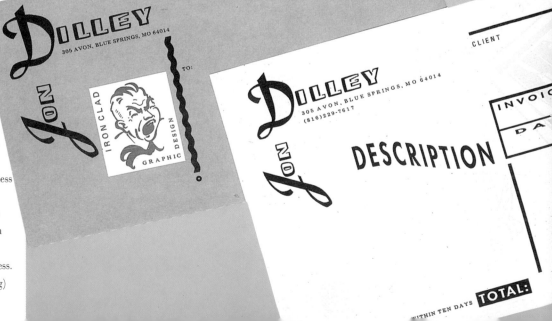

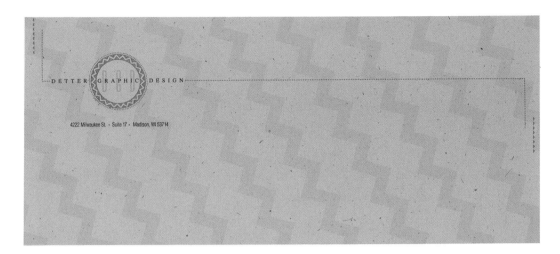

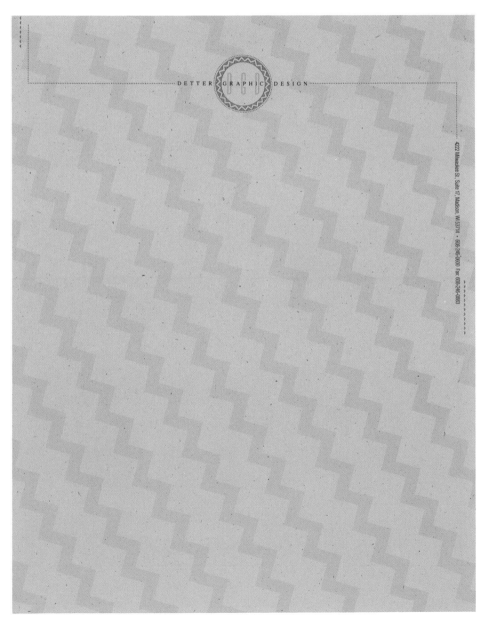

Art Director/Studio Jeanne Detter/ Detter Graphic Design, Inc.
Designer/Studio Detter Graphic Design, Inc.
Client/Service Detter Graphic Design, Inc., Madison, WI/graphic design
Paper French Paper Speckletone Verona Sky Recycled
Colors Two, match
Type Gable (DGD), Times Roman (client name), Triumvirate Condensed (remaining copy)
Printing Offset

Concept The designer wanted to create a letterhead that stands out in a stack of mail.
Special Visual Effects The stock creates a three-color effect, is eye-catching and is appropriate for a design studio. The designer also liked using recycled paper.
Cost-saving Technique The circular logo mark originated from a copy-right-free engraving.
Cost $1,200 (printing)

Designer Debra S. Hardesty

Illustrator Debra S. Hardesty

Client/Service Debra S. Hardesty, Sacramento, CA/illustration, retouching and hand-tinting

Paper Neenah Classic Crest

Colors Two, match

Type Perpetua Italic (letterhead, envelope, business card), Helvetica (invoice)

Printing Offset

Concept The checkered lizard symbolizes all of the artist's creative services—especially illustration and retouching—and shows her flair for the unusual. The symbol appears on standard letterhead components and on a second sheet of stationery, mailing label, invoice, notecard and 4 ³/₄ x 6 ¹/₂-inch envelope.

Budget $500 **Cost** $522 (paper; illustration was traded for printing)

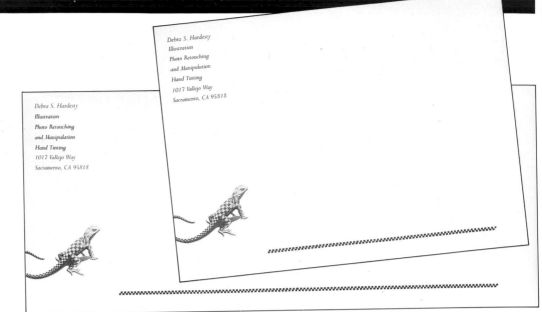

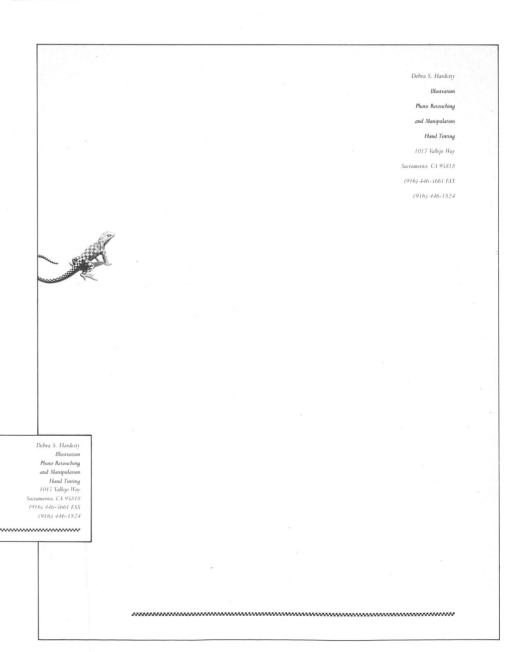

Danny Rodriguez Music
3016 Brian Allin ‖ El Paso, Texas 79936 ♭ (915) 591-4629

Danny Rodriguez
Composer/Music Theory
Trumpet Instructor

♯ ♭ ♮

**3016 Brian Allin
El Paso, Texas 79936
(915) 591-4629**

Danny Rodriguez Music
3016 Brian Allin ♮ El Paso, Texas 79936

Art Director/Studio Albert Juárez/ Albert Juárez Design & Illustrations
Designer/Studio Albert Juárez/Albert Juárez Design & Illustrations
Illustrator Albert Juárez
Client/Service Danny Rodriguez Music, El Paso, TX/music composition and instruction
Paper White Linen Stock
Colors One, match
Type Garamond Ultra Italic (client name and address), Garamond Book (remaining copy)
Printing Offset

Concept The client wanted a letterhead symbol to represent his musical services. The design solution is an eighth note that forms the client's first initial.
Cost-saving Technique The one-color printing, with the logo in black foil, kept costs down, while the black-on-white is true to the look of written music.
Budget None **Cost** $200 (design), $250 (printing)

TYPE

Designers/Studio Paula Richards,
Janet Bruscato, Bob Grindeland/
Team Design
Illustrator Bob Grindeland
Client/Service Team Design, Seattle,
WA/graphic design
Paper Nekoosa Bond
Colors Three, match
Type Empire (logo), Helvetica
Condensed (address)
Printing Offset

Concept The three studio partners
wanted a logo design that depicted a
team approach, rather than individ-
ual personalities. The solution also
needed to be bright and open to
reflect the studio's working environ-
ment.
Type The typeface was hand-drawn
on the computer. It was used
because of its weight and distinctive
styling, and because it managed to
be friendly yet businesslike.
Budget None **Cost** $1,500
(approximate, printing)

DIANN BISSELL
JANET BRUSCATO
BOB GRINDELAND

Tower Building
7th and Olive
Suite 500
Seattle
Washington
98101
206-623-1044
FAX Number:
206-625-0154

Tower Building
7th and Olive
Suite 500
Seattle
Washington
98101
206-623-1044
FAX Number:
206-625-0154

Tower Building
7th and Olive
Suite 500
Seattle
Washington
98101

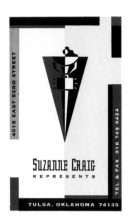

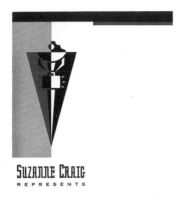

4015 E 53RD ST TULSA, OK 74135

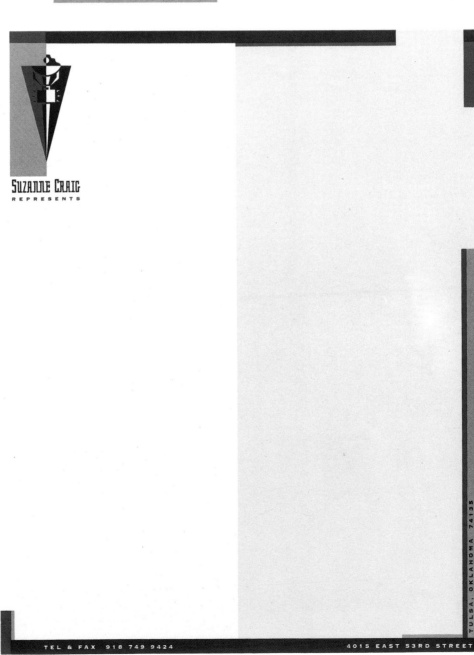

Designers/Studio Bill Gardner, Sonia Greteman, Susan Mikulecky/ Gardner Greteman Mikulecky
Client/Service Suzanne Craig Represents, Tulsa, OK/artists' representative
Paper Neenah Classic Crest Ivory
Colors Two, match
Type Oblong (client name), Copperplate (remaining copy)
Printing Offset

Concept The client wanted a hip, current feel that would represent her services and the portfolio of artists' work on equal terms, "so they both are stars." The designer's solution is a logomark featuring an abstractly stylized woman holding a radiating (prize) portfolio in her hands.
Type Oblong typeface, designed by Emigre Graphics, has the progressive and angular style that complements the logomark.
Cost-saving Technique One match color was screened two different percentages, creating the sense of more color without the cost of three-color printing.
Budget $3,000 **Cost** $1,500 (design), $1,500 (printing)

Designers/Studio Bill Gardner, Sonia Greteman, Susan Mikulecky/ Gardner Greteman Mikulecky
Client/Product Heart Thoughts, Wichita, KS/birth announcements
Paper Beckett Concept Desert Haze
Colors Three, match
Type Bernhard Modern Roman (address), Bernhard Modern Modified (logo)
Printing Offset

Concept The delicate flair of the ghosted logo and the metallic gold reflect the loving and religious nature of the client's birth announcements. The logo was designed to allow for future product expansion.
Type Gold thermography applied to the logo type and to the client's name kept costs down yet created the desired effect of foil stamping.
Special Production Technique A tinted varnish was applied to the ghosted logo.
Budget $3,000 **Cost** $1,500 (design), $1,500 (printing)

HEART THOUGHTS

6200 East Central • Suite 100 • Wichita, KS 67208 • Tel 316 688 5781

HEART THOUGHTS

Woodrow W. Goodvin, Jr.
Vice-President, Marketing
6200 E. Central • Suite 100 • Wichita, KS 67208
Tel 316 688 5781

HEART THOUGHTS

6200 East Central • Suite 100
Wichita, KS 67208

four commerce park square

23200 chagrin boulevard, suite 600, beachwood, ohio 44122-5498

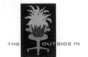

THE OUTSIDE IN

Designer/Studio Ruth D'Emilia/ Nesnadny & Schwartz
Client/Product The Outside In, Cleveland, OH/environmental design using plants
Paper Strathmore Writing (letterhead), Kimdura (business card)
Colors Three, match
Type Univers and Univers Condensed
Printing Offset

Concept The client wanted to convey that plantscaping has a positive effect on employees and should be part of any office. The designer's solution was to create a chair within a rectangle, representing a typical work environment, but with the unexpected addition of a plant.
Special Visual Effect The lively colors and cartoon-style illustration capture a friendly and inviting feeling.
Type The lowercase characters lend a feeling of informality, while the uppercase characters contrast with the complex visual. The positioning of the type creates a sense of moving "in and out."

THE OUTSIDE IN

a comprehensive approach to environmental design

charles e. adams, president

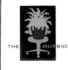

charles e. adams, president
216 292 8268 fax 216 464 7609

THE OUTSIDE IN

four commerce park square

23200 chagrin boulevard, suite 600

beachwood, ohio 44122-5498

a comprehensive approach to environmental design

four commerce park square, 23200 chagrin boulevard, suite 600, beachwood, ohio 44122-5498 216 292 8268 fax 216 464 7609

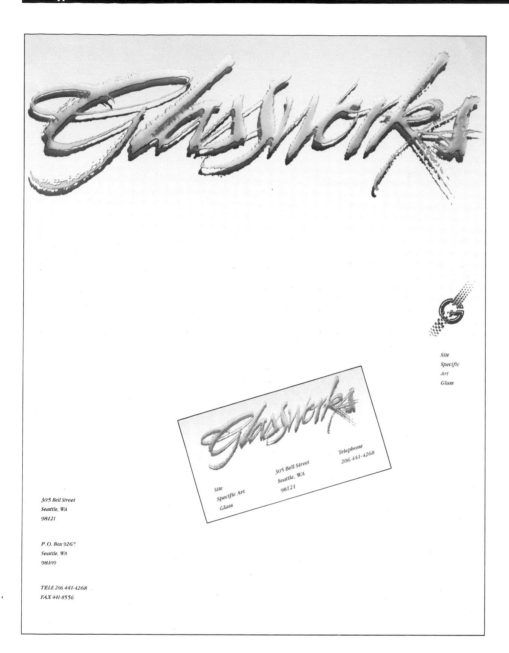

Art Director/Studio Jack Anderson/
Hornall Anderson Design Works
Designers/Studio Jack Anderson,
David Bates/Hornall Anderson
Design Works
Letterer Tim Girvin
Client/Service Glassworks, Seattle,
WA/site specific art glass
Paper Simpson Starwhite
Vicksburg Smooth Book
Colors Two, match
Type Hand-lettering (logo),
Palatino (remaining copy)
Printing Offset

Concept The client wanted his let-
terhead system to resemble a piece
of glass. Brush lettering was used for
the logo to offset the rigidity, flat-
ness and evenness associated with
glass. The smaller "G" logo shows a
process of change at different levels
and the ability to work and think in
three dimensions.
Special Production Technique An
actual brush technique was used to
hand-letter the original art for the
logo.

Designer/Studio Ivan Chermayeff/
Chermayeff & Geismar Inc.
Illustrator Ivan Chermayeff
Client/Service Tulip Films, Inc.,
New York, NY/film production
Paper Strathmore White
Colors Three, match
Type Hand-lettering
Printing Offset

Concept This simple but effective
design solution was inspired by the
name of the client company, whose
only requirement of the design was
that it be memorable. The design
was applied to a mailing label and
notepaper, as well as the standard
letterhead components.
Type The designer felt hand-letter-
ing would be true to the modest spir-
it of the image.
Special Production Technique The
tulip image was created by hand
using scissors and an X-acto knife.
Budget $2,470 **Cost** $1,186
(design), $1,284 (printing)

Tulip Films, Inc.
Penthouse
145 Sixth Avenue
New York, N.Y.
10013
Tel: 212.366.5096
Fax: 212.645.6232

Jonathan David

Tulip Films, Inc.
Penthouse
145 Sixth Avenue
New York, N.Y.
10013
Tel: 212.366.5096
Fax: 212.645.6232

Jonathan David

Tulip Films, Inc. Penthouse 145 Sixth Avenue New York, N.Y. 10013

Tulip Films, Inc. Penthouse 145 Sixth Avenue New York, N.Y. 10013

Designer/Studio Woody Pirtle/
Pentagram Design Inc.
Client/Service Libby Carton Design,
Brooklyn, NY/design
Paper French Paper Kraft
Colors Various, stamp pads
Type Univers
Printing Rubber stamps

Concept The designer created a
visual and tactile interpretation that
literally communicates the client's
name. The solution needed to be
flexible and inexpensive since the
client was likely to relocate.
Type Typography traditionally
identified with shipping carton
labeling is transferred to the rubber
stamp medium.
Special Production Techniques The
use of rubber stamps as the printing
method allows for endless variations
and adds a personal touch for this
one-woman organization.

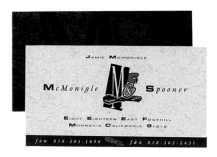

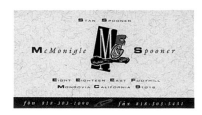

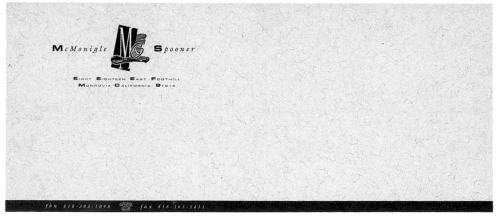

Designer/Studio Stan Spooner/ McMonigle & Spooner

Client/Service McMonigle & Spooner, Monrovia, CA/advertising and graphic design

Paper French Paper French Rayon Brocade Creme

Colors Four plus foil-front, one reverse, match

Type Galliard Italic (client names), Eurostile Extended (remaining copy)

Printing Offset

Concept The letterhead expresses this client's fresh and fun approach to design.

Special Visual Effect Foil stamping was applied to the logo. Enlarged portions of the logo are printed 100 percent black and 80 percent black on the backs of the letterhead and the business card, and on the inside of the envelope.

Type Using serif, sans serif bold and italic faces together contributes to the studio's light image. To limit the type on the business card, job titles were replaced with icons.

Budget None **Cost** None (design services were traded for printing)

Designers/Studio Bill Gardner,
Sonia Greteman, Susan Mikulecky/
Gardner Greteman Mikulecky
Client/Service Abell Pearson
Printing Company, Wichita, KS/
printing
Paper Beckett Concept Desert Haze
Colors Four, match
Type City
Printing Offset

Concept The client wanted a south-
west, art deco feel. Although each
style has individually been over-
done, the combination creates a
unique, contemporary look.
Special Visual Effect The logo's
robot man has a "hero" look that
implies the client can handle even
the hardest printing jobs. Bronze
metallic ink enhances this impres-
sion.
Type City typeface was chosen
because of its mechanical, precise
look in addition to integrating well
with the weight of the logo.
Budget None **Cost** None (printing
services traded for design services)

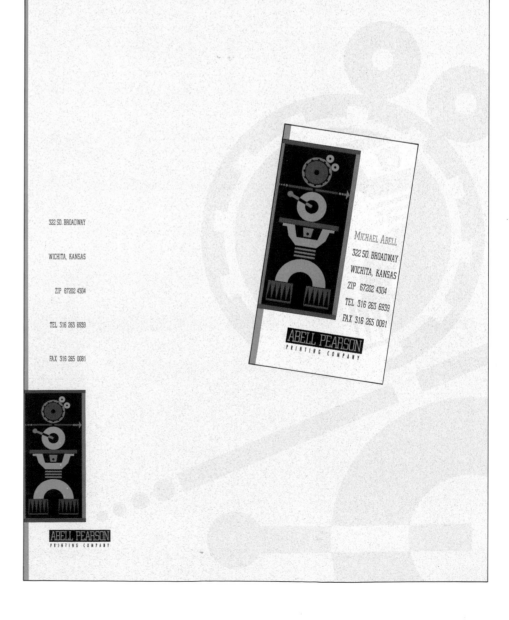

Art Director/Studio Henry Beer/
Communication Arts Incorporated
Designer/Studio David A. Shelton/
Communication Arts Incorporated
Client/Service Amador Land &
Cattle, Pleasanton, CA/land
development
Paper French Paper Speckletone
Ivory White
Colors Two, match
Type Garamond
Printing Engraving

Concept The logo design is based
upon the ancient symbol for cow,
which evolved into the letter "A". In
this letterhead application it is
drawn as a cattle brand.
Type The serif typeface appears
both friendly and traditional.
Cost $2,000 (design/printing)

AMADOR
LAND &
CATTLE
480 SAINT JOHN
SUITE 110
PLEASANTON,
CA 94566
415 462 4100
FAX 415 462 4397

AMADOR
LAND &
CATTLE
480 SAINT JOHN
SUITE 110
PLEASANTON,
CA 94566
415 462 4100
SAM W. BROWN, JR. FAX 415 462 4397

Bellegrove Medical Supply

1605 116th Ave. N.E. Suite 103

Bellevue, WA 98004

TEL 206.451.1319

TEL 800.352.1319

FAX 206.451.1329

Bellegrove Medical Supply

1605 116th Ave. N.E.

Suite 103

Bellevue, WA 98004

Art Director/Studio Bob Grindeland/
Team Design
Designer/Studio David Hastings/
Team Design
Client/Service Bellegrove Medical
Supply, Bellevue, WA/pharmaceuti-
cal supplies
Paper Beckett Concept
Colors Two, match
Type Futura Heavy (Bellegrove,
contact name), Caslon (remaining
copy)
Printing Offset

Concept The design goal was to
create a clean, simple letterhead that
projected a sense of trustworthiness.
The cross shape within the logo sug-
gests medical treatment.
Special Visual Effect The green tone
plays off operating-room green and
picks up the hue of the paper.
Type The letterforms within the
logo were hand-drawn on the
computer.
Cost $2,000 (design), $1,000
(printing)

Bellegrove Medical Supply

1605 116th Ave. N.E. Suite 103

Bellevue, WA 98004

TEL 206.451.1319

Barbara Fotheringill TEL 800.352.1319

Operations Assistant FAX 206.451.1329

Designer/Studio Jeff Runnion/
Runnion Design
Client/Service Red Cap Building
Services, Inc., Arlington, MA/
industrial cleaning service
Paper Simpson Protocol
Colors Two, match
Type Helvetica (Red Cap),
Helvetica Condensed (remaining
copy)
Printing Offset

Concept The client, on a very tight
deadline, wanted a logo and letter-
head design that clearly showed the
company's service.
Type The distinctively styled and
sized typefaces add visual interest
and enhanced readability to the long
name.
Budget $3,000 **Cost** $3,000 (logo
and letterhead design/printing)

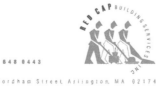

Art Director/Studio Jack Anderson/
Hornall Anderson Design Works
Designers/Studio Jack Anderson,
David Bates/Hornall Anderson
Design Works
Illustrator David Bates
Client/Service Vinifera Imports,
Ronkonkoma, NY/Italian wine
importing
Paper James River Tuscan Terra
Colors Two, match
Type Hand-lettering (logo),
Palatino (remaining copy)
Printing Offset

Concept The choice of paper, ink
color and type captures the feeling
of fine wine.
Special Visual Effect A subtle screen
as a background image mimics the
decorative corkscrew flourish in the
logo.
Type Foil was applied to the hand-
lettered logo type to enhance the
emboss and to achieve a richer,
more legible look.
Cost $6,000 (design/printing)

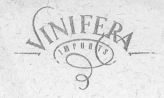

Vinifera
Imports
Ltd.

2190 Smithtown Ave.
Ronkonkoma, N.Y.
11779
(516) 467-5907

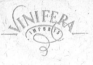

Robert Mackin

Vinifera Imports
Ltd.

2190 Smithtown Ave.
Ronkonkoma, N.Y.
11779

(516) 467-5907
FAX (516) 467-6516

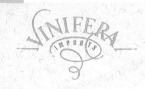

2190 Smithtown Ave.
Ronkonkoma, N.Y.
11779

Art Director/Studio Margo Chase/
Margo Chase Design
Designer/Studio Margo Chase/
Margo Chase Design
Client/Service James Bradley
Group, Los Angeles, CA/Macintosh
computer training, sales and
support
Paper Mohawk Superfine White
Colors Three, match
Type Custom-designed font
Printing Letterpress

Concept A strong design aesthetic
was needed for this client, whose
primary customers are designers.
The design also had to imply an
expert knowledge of computer
technology.
Type The use of a custom-designed
font for this client creates a high-
tech, leading-edge image.
Special Production Technique A
gloss varnish was applied to the
black ink. The bottom edge of the
letterhead and the envelope flap are
die cut.
Budget None **Cost** $8,000
(design/printing)

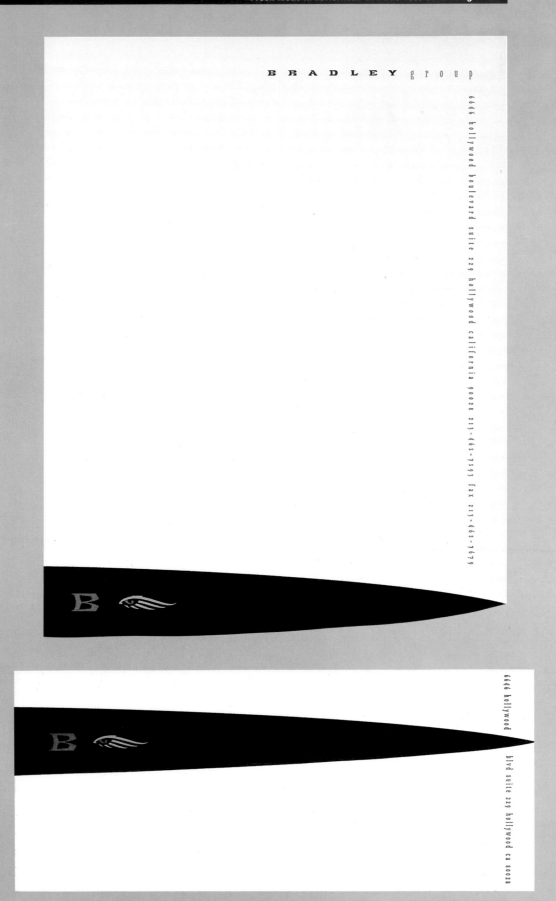

Art Director/Studio David Crowder/
Crowder Design
Designer/Studio Karen Klinedinst/
Crowder Design
Client/Service Weston Farm, Glen
Arm, MD/direct mail sales of
gourmet lamb
Paper Strathmore Writing Natural
Laid
Colors Two, match
Type Vivaldi (Lamb), Goudy
(remaining copy)
Printing Offset

Concept The client wanted a letter-
head that projected an organic
image for his farm, where livestock
are fed pesticide-free feed and grass.
The design was applied to small-
sized components: 5 1/2 x 8 1/2-inch
letterhead, 3 5/8 x 6 1/2-inch enve-
lope and a 4 x 5-inch mailing label.
Type The client felt that showing an
actual lamb could be counterpro-
ductive, so the use of an elegant, cal-
ligraphic typeface aptly expresses
the image of the animal.
Budget $5,000 **Cost** $4,500
(design/printing)

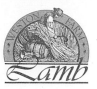

Designer/Studio Rudy VanderLans/ Emigre Graphics

Client/Service Emigre Graphics, Berkeley, CA/magazine and digital typeface software design

Paper Simpson Natural Recycled 70#

Colors One, process (letterhead and envelope); Two, process (business card and labels)

Type Oakland Six

Printing Offset

Concept The studio's identity and design emphases are obvious from this specialty typeface. The system includes a compliments card, mailing label and note card, as well as standard letterhead components.

Special Visual Effect A subtle background image is printed on the back of the letterhead sheets.

Type The face, designed by Zuzana Licko of Emigre Graphics, shows the design aesthetics and skills of the studio. The copy "Non-Stop Design" on the reverse of the compliments card was digitized to create a highly textured effect.

Cost-saving Techniques The color variety creates a lively appearance for the cost of only one- or two-color printing. The business card format and its design were also used for the mailing label.

Designer/Studio Tim Gant/
Gantdesign
Client/Service Cornerstone
Financial Group, Greenwood,
IN/insurance and financial planning
Paper French Paper Speckletone
Chalkwhite
Colors Two plus clear foil, match
Type Avant Garde (Financial
Group), Berling (remaining copy)
Printing Offset

Concept The client, a new business
whose partners possess extensive
experience, wanted a letterhead
image that subtly expressed classi-
cism and trustworthiness. Classic
type and the marble texture com-
bined to create this image.
Type The logo's capital "C" projects
the chiseled image of a cornerstone.
Cost-saving Technique A single die
was used to stamp the clear foil over
all applications of the logo.
Cost $2,300 (design/printing)

CORNERSTONE
FINANCIAL·GROUP

918 Fry Road, Suite C, Greenwood, IN 46142 /317/888-4112

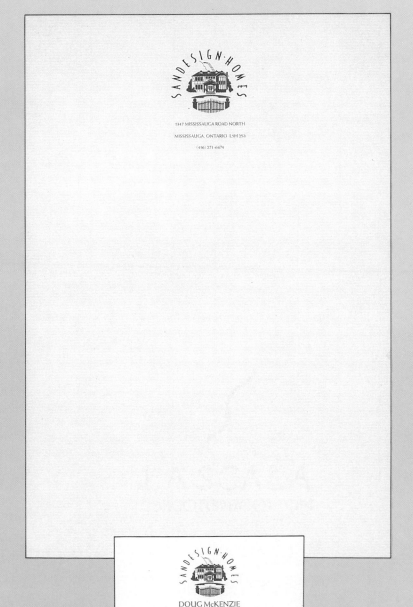

Designer/Studio Ric Riordon/The Riordon Design Group Inc.
Illustrator Bill Frampton
Typographer Karen Cheeseman
Client/Service Sandesign Homes, Mississauga, Ontario/luxury home development
Paper Rolland Papers La Scala Rigoletto Peach
Colors One, match
Type Custom (client name), Weiss (remaining copy)
Printing Offset

Concept This client—a new business with a limited budget—needed a design that said "quality." The choice of logo visual demonstrates the client's abilities, for it is the company's first development, as well as its office space.
Type The simple application of foil to the client's name combined well with the elegant visual.
Cost-saving Technique Using a magnesium rather than a brass die saved approximately $250. The smaller-sized letterhead and envelope allowed maximum use of the paper sheet while creating a look of distinction.
Budget $4,000 **Cost** $3,750 (design/printing)

WILLINGTOWN CONSTRUCTION

P.O. BOX 4
YORKLYN,
DELAWARE
19736

302•239•1800

WILLINGTOWN CONSTRUCTION

P.O. BOX 4
YORKLYN,
DELAWARE 19736

WILLINGTOWN CONSTRUCTION

P.O. BOX 4
YORKLYN,
DELAWARE 19736

302•239•1800

Pete Sanger

Designer/Studio Tony Ross/Ross Design Inc.
Illustrator Tony Ross
Client/Service Willingtown Construction, Yorklyn, DE/ construction
Paper Curtis Bright Water
Colors One, match
Type Futura
Printing Thermography, offset

Concept This design effectively uses illustrations to communicate information. The nails, wood shavings and stairsteps leave no doubt as to the client's business and add strong visual interest.
Type The use of illustration in lieu of type is an innovative approach to a "typographic" logo.
Special Production Technique The nails and the copy were thermographically printed. The nails' shadows and the corner visual were offset printed.
Cost $1,190 (design/printing)

Designer/Studio John Sayles/Sayles Graphic Design

Client/Service Sayles Graphic Design, Des Moines, IA/graphic design

Paper Neenah Classic Crest White

Colors Three, match

Type Hand-lettering (logo), Coronet (initial caps), Eurostile (remaining copy)

Printing Offset

Concept The studio wanted its system to reflect its innovative approach to design.

Special Visual Effects The letterhead is printed with 100 percent ink coverage on the back. The logo is black foil stamped, and the envelope uses an unusual side flap. The strong color palette ties in with the studio's bold design style.

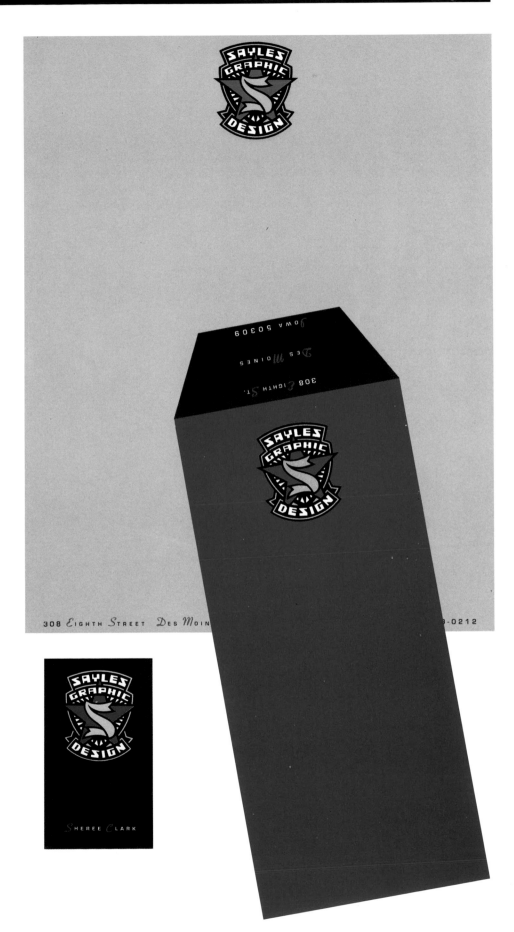

Designer/Studio Dan Wheaton/The Riordon Design Group Inc.

Client/Service M&M Chartered Accountants, Oakville, Ontario/ accounting and tax consultation

Paper Neenah Classic Crest Natural White

Colors Two, match

Type Arcadia (M), Gill Sans Bold (Chartered Accountants), Industria (remaining copy)

Printing Offset

Concept The logo type solution features letters with a fine contrast of dimension and form, while creating fresh corporate appeal and a conservative image.

Special Visual Effect The palette communicates an established corporate image. The client felt these colors looked prosperous.

Cost-saving Technique The second sheet was printed without names and addresses. The printer used the rub-off process, which uses chemicals to erase unwanted type from the plate while still positioned on the press.

Budget $3,300 **Cost** $3,000 (design/printing)

Michael H. Veitch, CA

Meeseong Veitch, CA

Accounting and Tax

Professionals

1309 McCraney St., E.

Oakville, Ont. L6H 3A3

(416) 842-3740

FAX

(416) 842-1360

Accounting & Tax

Professionals

1309 McCraney St., E.

Oakville, Ont. L6H 3A3

2 4 0 1
COLORADO
AVENUE
SUITE 110
●
SANTA
MONICA
CALIFORNIA
9 0 4 0 5
●
2 1 3
820·0107
●
F A X
2 1 3
453·7732

2 4 0 1
COLORADO
AVENUE
SUITE 110
●
SANTA
MONICA
CALIFORNIA
9 0 4 0 5

Designers/Studio Jamie McMonigle, Stan Spooner/McMonigle & Spooner
Client/Service International Sports Development Programs, Inc., Santa Monica, CA/international basketball sporting event promotion
Paper Neenah Avon Bright White
Colors Two, match
Type Futura and Futura Condensed
Printing Offset, thermography

Concept The client, who promotes racial and international harmony through sporting events, including youth basketball camps, needed its letterhead to communicate its business to non-English-speaking clients.
Type Futura gives the design a classic and contemporary feel. The condensed version works well in the vertical format, while the noncondensed "O"s reinforce the globe and athletic balls.

Special Production Techniques
Thermography was an inexpensive method for adding three-dimensionality.

Budget $1,000 **Cost** $863 (printing)

Art Director/Studio Margo Chase/
Margo Chase Design
Designer/Studio Margo Chase/Margo
Chase Design
Client/Service Smashbox, Santa
Monica, CA/photographic studio
rental
Paper French Paper Speckletone
Chipboard Text and Cover
Colors One plus two foils, match
Type Steile Futura
Printing Letterpress plus foil stamp

Concept The abstract logotype,
based on a camera bellows, or
"smash box," gave this client a look
that is hip, but professional. The
logo was applied to clear labels,
mailing labels and a 4 x 9-inch mul-
tifunctional card, as well as standard
letterhead pieces.
Special Visual Effect Black and
metallic copper foils create a strong
contrast between the rough stock
and the smooth logo. The copper
color plays off the distressed metal
used in the photo studio.
Type Letterforms were customized
to communicate the "smashed" cam-
era bellows concept.
Cost $4,400 (design/printing)

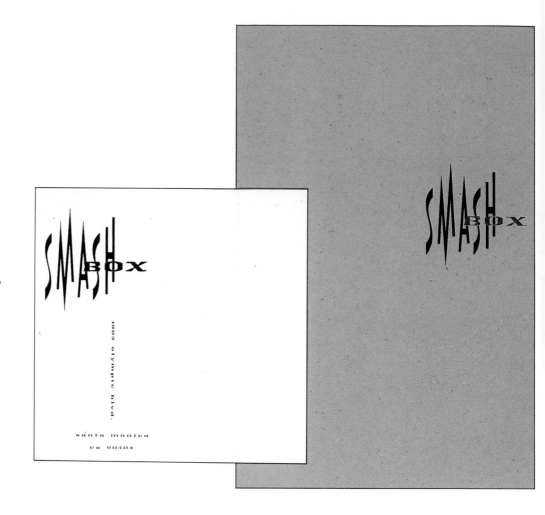

5841 SUNSHINE CANYON BOULDER COLORADO 80302 USA TELEPHONE/FAX 303-444-5925

Art Director/Studio Richard Foy/
Communication Arts Incorporated
Designer/Studio Hugh Enockson/
Communication Arts Incorporated
Client/Service Andy Katz
Photography, Boulder, CO/photog-
raphy
Paper Simpson Starwhite
Vicksburg High Tech Tiara White
Colors Three, match
Type Compacta Light (logo),
Futura Light Condensed (remaining
copy)
Printing Engraving

Concept This design makes subtle
reference to the client's profession
without resorting to cliched pic-
tographs or symbols. The solution is
suitable for the client's two areas of
business: artistic and commercial
photography.
Type An all-type design capitalizes
on the memorableness of having
four letters in the client's first and
last names.
Special Production Technique
Because a square-flap envelope did
not exist in this stock, the envelope
was produced and converted so the
paper direction matched that of the
other pieces in the system.
Budget $2,500 **Cost** $2,000
(design/printing)

5841 SUNSHINE CANYON BOULDER COLORADO 80302 USA

RICK MULROONEY

WRITER

405

WEST

22ND ST.,

WILMINGTON,

DELAWARE

19802

302 571 1889

RICK MULROONEY

WRITER

405
WEST
22ND ST.,
WILMINGTON,
DELAWARE
19802
302 571 1889

RICK MULROONEY

WRITER

405
WEST
22ND ST.,
WILMINGTON,
DELAWARE
19802

Designer/Studio Tony Ross/Ross Design Inc.
Illustrator Tony Ross
Client/Service Rick Mulrooney, Wilmington, DE/copywriting
Paper Simpson Gainsborough
Colors Two, match
Type Futura
Printing Offset

Concept Creativity and uniqueness were the two qualities the client wanted his letterhead design to show.
Type The logo's hand-drawn type solution incorporates many dimensions: the client's name, reference to his profession and an implied sense of creativity. Futura for the copy mirrors the boldness of the logo.

Art Director/Studio Margo Chase/
Margo Chase Design
Designer/Studio Margo Chase/
Margo Chase Design
Client/Service Elaine Cossman, Los
Angeles, CA/ad copywriting
Paper Simpson Protocol
Colors Three, match
Type Trajanus
Printing Letterpress

Concept This logo was designed to
communicate the client's humorous
writing style. The system includes a
standard-size sheet and envelope, as
well as a mailing label, 4 x 9-inch
multifunctional notecard and single-
fold business card.
Special Visual Effect The logo is
modified on the mailing label and
business card to show the pen flying
out of the crossbow.
Special Production Technique White
ink is printed behind the crossbow
logo.
Type The placement of type near
the pen "points" to the client's name
and creates a sense of direction and
movement.

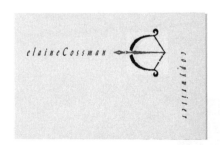

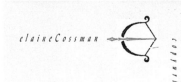

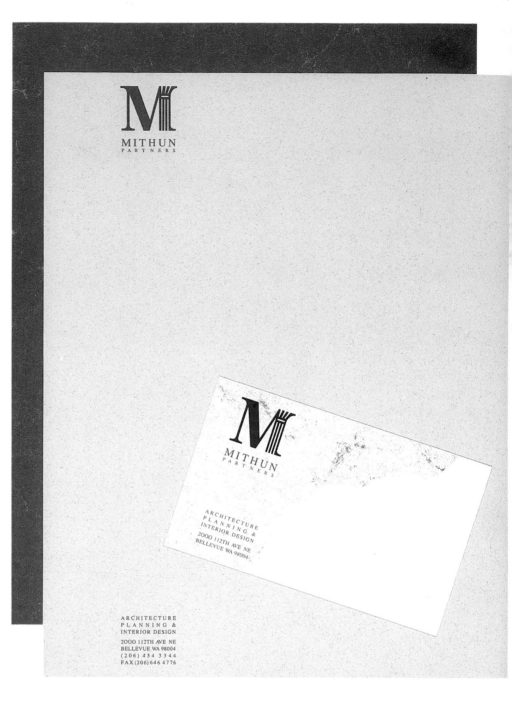

Art Director/Studio Jack Anderson/
Hornall Anderson Design Works
Designers/Studio Jack Anderson,
Cliff Chung, Brian O'Neill/Hornall
Anderson Design Works
Client/Service Mithun Partners,
Seattle, WA/architectural planning
and interior design
Paper Curtis Flannel Silver Mist
Colors Two, match
Type Times Roman Manipulated
(M), Times Roman (remaining
copy)
Printing Offset

Concept The overall look needed to
say "architecture," "sophistication"
and "high quality." The system
added a mailing label to the stan-
dard components.
Special Visual Effect Marbleized
papers and sophisticated colors
depict the firm's high-quality and
classic architectural style.
Type The letter "M" integrated with
a classic column creates a solid plat-
form for the logo and the concept.
Budget $20,000 **Cost** $22,000
(design/printing)

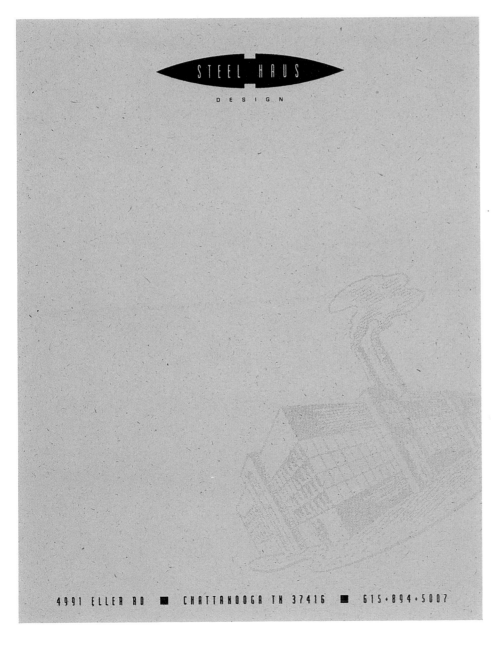

Designer/Studio Richard L. Smith/
Steelhaus Design
Client/Service Steelhaus Design,
Chattanooga, TN/graphic design
Paper French Paper Speckletone
Kraft
Colors One, process
Type Modula (logo), various
(remaining copy)
Printing Offset

Concept This low-budget system
needed to express the industrial
image of the studio. The design was
applied to an invoice as well as stan-
dard letterhead pieces.
Type Modula is a custom font
designed by Emigre Graphics.
Cost-saving Technique One-color
printing, computer-generated type
and graphics, and an inexpensive
paper stock combined to keep costs
down.
Cost $250 (design/printing)

VISUAL EFFECT

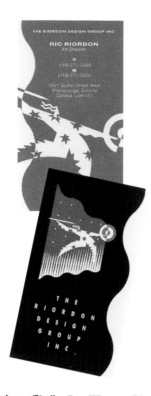

Designers/Studio Dan Wheaton, Ric Riordon/The Riordon Design Group Inc.
Illustrator Bill Frampton
Client/Service The Riordon Design Group Inc., Mississauga, Ontario/graphic design
Paper Classic Crest Solar White
Colors Five, match
Type Futura Bold Condensed (client name), Helvetica Light (remaining copy)
Printing Offset

Concept The figure represents the studio's creative spirit; the pencil, its tools and craft; and the bull's-eye, the goal of meeting client objectives. A pictogram communicates these ideas simply.
Cost-saving Technique The studio printed extras of all components without the address so a future move would only require a two-color imprint.
Budget $7,000 **Cost** $7,200 (design/printing)

Designer/Studio Tony Ross/Ross Design Inc.
Client/Service Chuck Selvaggio, Wilmington, DE/disc jockey
Paper Unknown
Colors Two, match
Type Helvetica
Printing Offset

Concept The bleeding graphic, background texture and open-letter spacing produce the look the client wanted: trendy and New Wave.
Special Visual Effects The purple triangles in the center of the card point to and lead the viewer's eyes toward the client's phone number; the phone number is further emphasized by a purple jagged border that echoes these triangles.

CHUCK
SELVAGGIO
▼
DISC
JOCKEY
▼
MUSIC FOR
EVERY OCCASION
▼

3 0 2 7 6 4 8 0 7 0

Designer/Studio Tony Ross/Ross Design Inc.
Illustrators Tony Ross, Conrad Velasco
Client/Service Zohra Spa & Clinique, Wilmington, DE/spa
Paper Howard Linen
Colors Two, match
Type Palatino
Printing Offset

Concept The objective, a challenge to accomplish in a small space, was to show that the client's entire line of products and services have some connection to the ocean.
Special Visual Effects The single fold lets the card open to 2 1/8 x 6 1/2 inches, giving the client more space for copy than a standard format card would have.

Art Directors/Studio Joel Fuller, Lisa Ashworth/Pinkhaus Design Corp.
Designers/Studio Lisa Ashworth, Mark Cantor/Pinkhaus Design Corp.
Client/Service Atlanta Artists, Miami, FL/record production
Paper French Paper Speckletone Natural Cover
Colors Three, match
Type Futura
Printing Offset

Concept This client needed a business card designed and printed in only three days. The funky, double "A" logo design represents the client's name, with the flying compact disc sending out "vibes" to the world.
Special Visual Effect The bold colors and earthy paper reflect the personality and style of the client.
Cost $541 (printing)

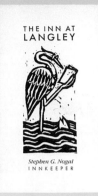

Art Director/Studio Ellen Ziegler/
Ellen Ziegler Design
Designer/Studio Sara Ledgard/Ellen
Ziegler Design
Illustrator Fred Hilliard
Client/Service The Inn at Langley,
Whidbey Island, WA/hotel and
restaurant
Paper Simpson Starwhite Vicksburg
Natural
Colors One, match
Type Futura Book
Printing Offset

Concept The creative goal was to
present a rustic and whimsical yet
sophisticated image that reflected the
personality of this small luxury hotel
and restaurant. The client wanted a
design that communicated to guests
exactly what to expect.
Special Visual Effect The blue
heron, chosen because it is indige-
nous to the client's location, was ren-
dered in linoleum block by an illus-
trator who is skilled at creating
whimsical images but had never
worked in that medium. The inten-
tion was to give the image its
rougher look.
Budget $7,500 **Cost** $2,500
(design/printing)

THE INN AT LANGLEY PO BOX 835 400 FIRST STREET LANGLEY WHIDBEY ISLAND WASHINGTON 98260 206 · 221 · 3033

THE INN AT LANGLEY PO BOX 835 400 FIRST STREET LANGLEY WHIDBEY ISLAND WASHINGTON 98260

Carroll Morgan Photography

Carroll Morgan Photography

Carroll Morgan Photography

1010 BUNNELL ROAD
SUITE 1102
ALTAMONTE SPRINGS, FLORIDA 32714
TELEPHONE 407.862.2224
FACSIMILE 407.862.4775

Art Director/Studio Jeff Matz/
McQuien Matz
Designer/Studio Jeff Matz/McQuien
Matz
Client/Service Carroll Morgan
Photography, Altamonte Springs,
FL/photography
Paper Beckett Concept Desert Haze
Colors Two, match
Type Cochin (client name),
Copperplate (remaining copy)
Printing Offset

Concept The designer used old fonts
and a soft color palette to give this
letterhead system a warm tone.
Special Visual Effect The back-
ground pattern, reproduced from a
black-and-white print made by the
client, recalls his style of work.
Special Production Technique
Budget restrictions prevented con-
version of the envelopes, so they
were vignetted rather than bled.
Cost $580 (printing; design was
traded for photography services)

1010 BUNNELL ROAD
SUITE 1102
ALTAMONTE SPRINGS, FLORIDA 32714
TELEPHONE 407.862.2224
FACSIMILE 407.862.4775

RADIO VISION
INTERNATIONAL
AVON HOUSE
FOURTH FLOOR
360 OXFORD ST
LONDON
W1N9HA UK
PH: 71 493 0439
FAX: 71 493 0421

RADIO 🕱 VISION

RADIO VISION
INTERNATIONAL
7060 HOLLYWOOD
BLVD 5TH FLOOR
HOLLYWOOD
CA 90028 USA
PH: 213 469 5750
FAX: 213 469 5599
TELEX: 9103809476

DAVID KNIGHT
VICE PRESIDENT, ACQUISITIONS

AVON HOUSE
FOURTH FLOOR
360 OXFORD ST
LONDON
W1N9HA UK
PH: 71 493 0439
FAX: 71 493 0421

Art Director/Studio Margo Chase/ Margo Chase Design

Designer/Studio Margo Chase/ Margo Chase Design

Client/Service Radio Vision International, Los Angeles; London/broadcast distribution of live concert videos

Paper Potlatch Mountie Matte White

Colors Three, match

Type Custom (client name), Futura (remaining copy)

Printing Offset

Concept The designer sought a strong yet simple symbol to communicate the client's style. The design was applied to the oversized letterhead, business card and postcard; the off-sized envelope; and various self-sticking labels.

Special Visual Effect The background graphics, a photogram of the logo, symbolize a moving image in a music video. The color scheme creates a sophisticated, serious look.

Cost $14,000 (design/printing)

Art Director/Studio Woody Pirtle/
Pentagram Design Inc.
Designer/Studio Woody Pirtle/
Pentagram, Leslie Pirtle/Freelance
Illustrator Woody Pirtle
Typographer Monogram
Client/Service Jonathan and Mary
Alexander, New York; London/per-
sonal stationery
Paper Champion Carnival Softwhite
Text 70#
Colors Four, process
Type Garamond No. 3
Printing Offset

Concept The clients, who split their
time between two cities, needed a
letterhead that would serve them on
two continents. This 11 x 17-inch,
single-fold letterhead design lets
them flip to whichever address side
fits their current residence. The sys-
tem includes two differently
addressed mailing labels.
Special Visual Effect The map illus-
trations originated from antique
maps.

Art Director/Studio Thomas Scott, Jeff Matz, Ron McQuien/McQuien Matz

Designer/Studio Thomas Scott, Jeff Matz/McQuien Matz

Client/Service The Jake Allen Center for Deaf-Blind Children, Zellwood, FL/care and education of deaf-blind children

Paper Neenah Environment White

Colors Three, match

Type Bulmer

Printing Offset

Concept This system features the client's new mark, which depicts the school's one-to-one student-teacher relationships.

Special Visual Effect Because the letterhead is used primarily for fund-raising, the designer wanted the color scheme to feel warm but corporate, to maintain credibility.

Type The typeface and its treatment are understated and tasteful, speaking volumes at a small size.

Budget None **Cost** None (all services were donated)

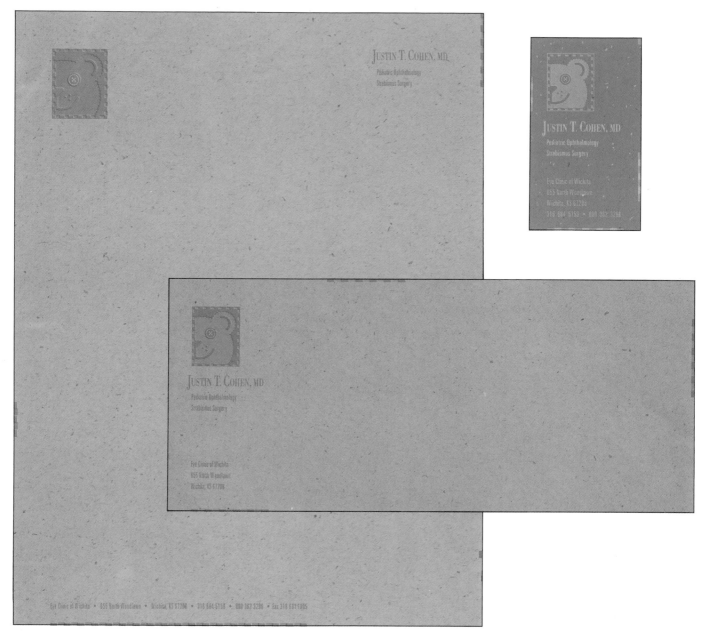

Designer/Studio Bill Gardner, Sonia Greteman, Susan Mikulecky/ Gardner Greteman Mikulecky

Client/Service Dr. Justin Cohen, Wichita, KS/pediatric ophthalmologist

Paper French Paper Speckletone Kraft

Colors Two, match

Type Bauer Bodoni (client name), Swiss Light Extra-Condensed (remaining copy)

Concept The goals of this system were to present a friendly, warm, yet professional image.

Special Visual Effects The designer used a bright color palette, a friendly logo and a low-key, teddy-bear-colored paper stock to communicate the client's manner of comforting pediatric surgery patients.

Budget $3,000 **Cost** $1,500 (design), $1,500 (printing)

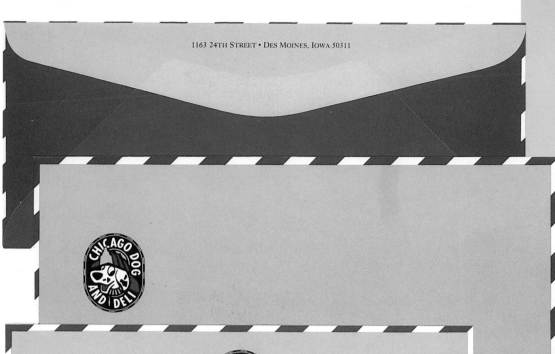

1163 24TH STREET • DES MOINES, IOWA 50311

1163 24TH STREET
DES MOINES, IOWA
50311
(515) 277-3647
(515) 277-DOGS

MARCI PETERS

Designer/Studio John Sayles/Sayles Graphic Design

Illustrator John Sayles

Client/Product Chicago Dog & Deli, Des Moines, IA/Chicago-style hot-dogs served in a renovated firehouse

Paper Neenah Classic Crest White

Colors Three, match

Type Futura Condensed (client name), Bookman (remaining copy)

Printing Offset

Concept This stationery brings to mind every possible image associated with a firehouse and hot dogs: a dog (he's even a Dalmatian), a firehouse (his classic hat), sirens (the red border) and mustard (the gold-colored ink).

Special Visual Effect To reinforce the striking design, the inside of the envelope and the backs of the letterhead, business card and envelope inside were printed 100 percent red.

1163 24TH STREET • DES MOINES, IOWA 50311 • (515) 277-3647 • (515) 277-DOGS

Art Director/Studio Jeff Matz/
McQuien Matz
Designer/Studio Jeff Matz/McQuien
Matz
Client/Service Toronto Sun
Publications, Winter Park, FL/
newspaper publishing
Paper Neenah Classic Crest Avon
Brilliant White
Colors Four, process
Type Futura Medium Condensed
Printing Offset

Concept The design solution visual-
izes the delivered newspaper tossed
into a yard or onto a porch or drive-
way. The designer felt people would
relate quickly to this recognizable
idea.
Special Visual Effect The logo fea-
tures Orlando, Florida, the area in
which the newspaper is distributed.
The image originated from a comp
of the publication, produced prior to
its printing.
Cost Approximately $8,400
(design/photography/printing)

809 S ORLANDO AVE, SUITE O • WINTER PARK, FL 32789 TELEPHONE 407 645 5888 • FACSIMILE 407 645 2547

GLORIA JOHNSON
ACCOUNT EXECUTIVE

809 S ORLANDO AVE, SUITE O
WINTER PARK, FL 32789
407 645 5888
FAX 407 645 2547

CENTRAL FLORIDA'S NEWS AND ENTERTAINMENT MAGAZINE

THE WEEKLY • CENTRAL FLORIDA'S NEWS & ENTERTAINMENT MAGAZINE • A TORONTO SUN PUBLICATION

809 S ORLANDO AVE, SUITE O WINTER PARK, FL 32789

CENTRAL FLORIDA'S NEWS AND ENTERTAINMENT MAGAZINE

Stephen I. Pelton, M.D.
Vice Chairman
Department of Pediatrics

Designer/Studio Jeff Runnion/
Runnion Design
Illustrators Jeff Runnion, Sandy
Runnion
Client/Service Boston City Hospital
Pediatrics, Boston, MA/hospital
Paper Strathmore Renewal
Colors Three, match
Type Janson Italic (pediatrics),
Futura Condensed (remaining copy)
Printing Offset

BCH*Pediatrics*
▲▲▲▲▲▲▲▲▲▲▲

Boston City Hospital 818 Harrison Avenue Talbot 115 Boston, MA 02118

BCH*Pediatrics*
▲▲▲▲▲▲▲▲▲▲▲

Boston City Hospital 818 Harrison Avenue Talbot 115 Boston, MA 02118 617 - 534 - 7408

Concept The client, an innercity
hospital with primarily minority
patients, was refurbishing its image
and facilities. This department's
new logo and letterhead needed to
appear fun and illustrate the range
of children it treats. Portions of
other versions of the letterhead type
are printed in Spanish and in
Haitian-Creole.

Special Visual Effects The logo
illustration had to look childlike yet
polished. The colors have a bright
yet unique quality. Some of the tex-
ture in the clothing was stripped in
from actual fabric.

Budget $3,000 **Cost** $3,000 (logo
and letterhead design/printing)

Boston City Hospital
818 Harrison Avenue
Talbot 115
Boston, MA 02118
617 - 534 - 7408

Stephen I. Pelton, M.D.
Vice Chairman, Department of Pediatrics

BCH*Pediatrics*
▲▲▲▲▲▲▲▲▲▲▲

Designer/Studio John Sayles/Sayles Graphic Design

Client/Service Buena Vista College, Storm Lake, IA/higher education

Paper James River (special mill order)

Colors Three, match

Type Futura (client name), Palatino (remaining copy)

Printing Offset

Concept This letterhead was designed for the college president during the school's centennial celebration. The design needed to coordinate with the college letterhead but be more subdued. The challenge was to maintain both the festive feeling of the centennial celebration and the credibility of the president's office.

Special Visual Effect The designer ran the college logo very large and screened back on the letterhead and envelope, similar to a watermark. The two dominant colors, navy blue and gold, are the college colors; the burgundy and purple are attractive accents.

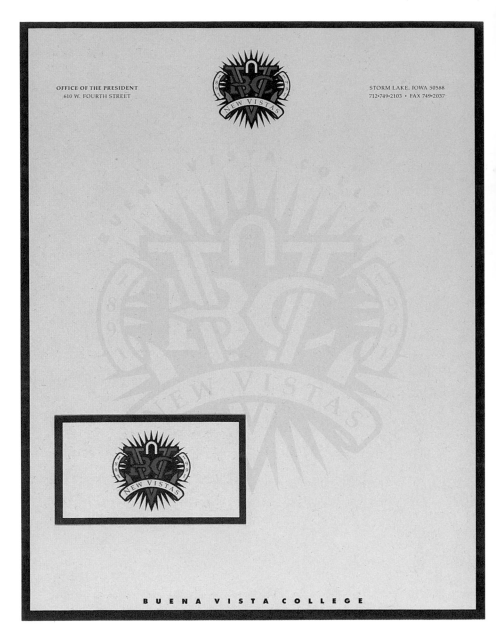

Michael A. Palisi

4095 Route U.S. 1, Suite 52-220

Monmouth Junction, N.J. 08852

Telephone 609-936-0139

4095 Route U. S. 1 · Suite 52-220 · Monmouth Junction, New Jersey 08852 · Telephone 609-936-0139

Designer/Studio Bill Gardner, Sonia Greteman, Susan Mikulecky/ Gardner Greteman Mikulecky

Client/Service Poorsports, Monmouth Junction, NJ/wholesale brokering of sporting goods equipment

Paper Neenah Classic Crest

Colors Two, match

Type Liberty (script), Custom (logo), Futura Bold (remaining copy)

Printing Offset

Concept The designer produced a bright, novel image for a novel business. The referee logo depicts the irreverent fun of sports.

Special Visual Effects The black-and-white stripe along the entire flap fold and the yellow—reminiscent of penalty flags—on the front and back of the envelope reinforce the effect of the referee logo. A special envelope conversion was required to print these elements.

Budget $3,000 **Cost** $2,000 (design), $1,000 (printing)

Creative Director/Studio Roger Perry/Winner Koenig & Associates
Art Director/Studio Jayne Alfieri/ Winner Koenig & Associates
Designer/Studio Jayne Alfieri/ Winner Koenig & Associates
Illustrator Jayne Alfieri
Client/Service Rehabilitation Living Centers, Inc., New Orleans, LA/ annual brain injury rehabilitation symposium
Paper Strathmore Writing Bright White
Colors Four, match
Type Bank Gothic Medium
Printing Offset

Concept The design reflects the international scope of the symposium. The hemispheres depicted in the logo represent brain hemispheres, which the client did not want shown.
Special Visual Effects A tinted varnish was applied to the background art. The map was printed on the front and back of the envelope prior to conversion.
Cost-saving Techniques The background art uses a public domain map. The simple logo art was produced easily in house.
Budget $7,500 **Cost** $7,425 (design/printing)

Designer/Studio Tony Ross/Ross Design Inc.

Illustrators Tony Ross, Mark Lee

Client/Service The Polo Club Restaurant, Greenville, DE/ restaurant

Paper Gilbert Oxford

Colors Three, match

Type Palatino (The Polo Club), Futura Condensed (remaining copy)

Printing Offset

Concept The overall design reflects the personality and interior design of the restaurant. The design was also applied to a menu, not shown here.

Special Visual Effect The large graphics and their eye-level perspective create a strong sense of viewer involvement.

3801 Kennett Pike • P.O. Box 4521 • Greenville, DE 19807 • Restaurant 302.655.8000 • The Club Room 302.571.9010

3801 Kennett Pike
P.O. Box 4521
Greenville, DE 19807

Art Director/Studio Jack Anderson/ Hornall Anderson Design Works
Designer/Studio Jack Anderson/ Hornall Anderson Design Works
Photographer Greg Krogstad
Client/Service Carlson/Ferrin Architects, Seattle, WA/architecture
Paper Simpson Protocol
Colors Two, match
Type Bauer (client name), Helvetica (remaining copy)
Printing Offset

Concept Stair and window/door shapes create the sense of three dimensions on flat paper, similar to the way architects work. The design was applied to a mailing label as well as standard letterhead pieces.
Special Visual Effect The different spot colors on each component signify the architect's diverse use of color.
Special Production Technique To create the image, a white model was photographed and the black-and-white prints were touched up with airbrush.

Designer/Studio Jamie McMonigle/ McMonigle & Spooner

Client/Service Ocean States, Santa Monica, CA/energy-efficient lighting and fixture renovation

Paper Simpson Evergreen Text Hickory

Colors Three, match

Type Lithos Black (client name), Lithos (remaining copy)

Printing Offset

Concept This logo and letterhead design gave the client the unique image it needed to stand out in its marketplace.

Special Visual Effect The bleeding background texture and a "floating" logo create a jarring effect. The slight bleed of the logo added visual interest.

Special Production Technique The envelope's logo wrapped around the top flap to avoid a bleed that could have stopped short of the fold due to variations in registration.

Cost $1,200 (design; compensation also included an upgrade of the studio's energy and lighting systems), $800 (printing)

Designer/Studio Stan Spooner/
McMonigle & Spooner
Client/Service Interiors by Design,
Covina, CA/full-service interior dec-
orating and furniture upholstering
Paper Unisource Sundance Felt
Natural White
Colors Three, match
Type Lithos (Interiors), Zapf
Chancery (remaining copy)
Printing Offset

Concept The client, known for its
bold and varied styling, wanted a
fun logo and letterhead design that
gave an intriguing view of as many
of their services as possible.
Special Visual Effect The original
art for the logo was a linocut, from
which a section of the rolled-up rug
was enlarged to create the back-
ground texture.
Cost-saving Technique The logo was
reproduced the same size on all
pieces, and the entire system was
gang-printed with another letter-
head job.
Budget $600 **Cost** $600 (printing;
design was traded for services from
the client)

INTĔGRUS
ARCHITECTURE

WEST 244 MAIN AVENUE
SPOKANE, WA 99201
P.O. BOX 1482 (99210)

FAX 509.838.2194
509.838.8681

Larry D. Hurlbert
William A. James
Gary D. Joralemon
Bruce F. Mauser
George H. Nachtsheim
Arthur A. Nordling
John Plimley
Gordon E. Ruehl
Thomas M. Shine
Bruce M. Walker
Gerald A. Winkler
Kirklund S. Wise

The WMFL & ECI traditions continue.

INTĔGRUS
ARCHITECTURE

CRAIG CARO

WEST 244 MAIN AVENUE
SPOKANE, WA 99201
P.O. BOX 1482 (99210)

FAX 509.838.2194
509.838.8681

The WMFL & ECI traditions continue.

Art Director/Studio Jack Hornall/Hornall Anderson Design Works
Designer/Studio John Hornall, Paula Cox, Michelle Rieb, Brian O'Neill, Lian Ng/Hornall Anderson Design Works
Client/Service Integrus, Spokane, WA/architecture
Paper Neenah Environment
Colors Five, match
Type Bodoni (logo), Helvetica Condensed Light (remaining copy)
Printing Offset

Concept The multiplicity of the client's employees and their ideas gave rise to the use of a flexible format and the organic illustrative forms, related to grids. This solution, which is applied to a mailing label in addition to standard letterhead components, reflects the client's history of environmental sensitivity.
Special Visual Effect The animal/insect visuals indicate size relationship, which is an idea found originally in nature and is the basis for architecture.

INTĔGRUS
ARCHITECTURE

The WMFL & ECI traditions continue.

INTĔGRUS
ARCHITECTURE

915 SEATTLE TOWER
1218 THIRD AVENUE
SEATTLE, WA 98101-3018

The WMFL & ECI traditions continue.

Art Director/Studio Joe Parisi, Tim Thompson/Graffito

Designer/Studio Joe Parisi/Graffito

Photographer Morton Jackson

Client/Service Kapcom, Silver Spring, MD/video production

Paper Proterra Global Blue Text 80#

Colors Two, match

Type Custom font and Franklin Gothic (logo), Industria (address), Franklin Gothic (remaining copy)

Printing Offset

Concept To project a progressive image, the designer chose to depict the camera as a "thinking" tool. The design was applied to a mailing label as well as standard letterhead pieces.

Special Production Technique The job made a third pass on the press to print the yellow over the black and create the ghosted effect.

Cost $9,000 (design/printing)

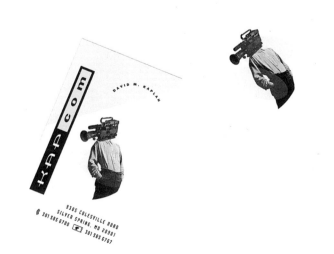

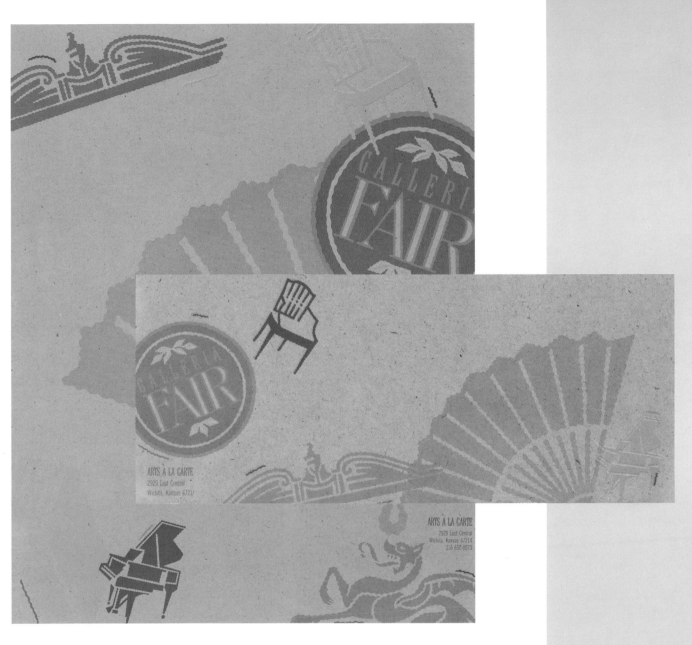

Designer/Studio Bill Gardner, Sonia Greteman, Susan Mikulecky/ Gardner Greteman Mikulecky
Client/Product Galleria Fair, Wichita, KS/antiques and collectibles
Paper French Paper Speckletone Kraft
Colors Four, match
Type Latin Hand Modified (client name), Swiss (remaining copy)
Printing Offset

Concept The client wanted his store to be seen as a fun, off-the-beaten-trail place in which to linger, eat, buy fresh flowers and enjoy the day. The letterhead design conveys this almost fairlike image.
Special Visual Effect The graphics visually explore the store's diverse array of products. Vivid colors play off the Kraft paper, which the designer intended to dull the spontaneity of the palette.
Budget $3,000 **Cost** $1,500 (design), $1,500 (printing)

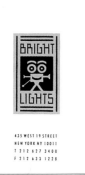

Art Director/Studio Woody Pirtle/ Pentagram Design Inc.
Designer/Studio Woody Pirtle, Penny Rowland/Pentagram Design Inc.
Client/Service Bright Lights, New York, NY/film production
Paper Kimberly Clark Writing 24#
Colors Two, match
Type Hand-lettering (logo), Futura Bold Condensed (remaining copy)
Printing Offset

Concept This start-up film production company wanted a fun image. Pentagram's solution is a black and bright yellow animated camera symbol, applied to a single-fold video-cassette label and mailing label, as well as standard letterhead pieces.

Designer/Studio Bill Gardner, Sonia Greteman, Susan Mikulecky/ Gardner Greteman Mikulecky

Client/Service Wichita TeamTennis (Advantage Wichita), Wichita, KS/professional tennis team

Paper Neenah Classic Crest Avon Brilliant White

Colors Four, match

Type Bank Gothic

Printing Offset

Concept According to this design studio, most tennis logos are staid and static. This system was created to show the grace, energy, rhythm and balance of the sport.

Special Visual Effects The back of the letterhead and business card and the inside of the envelope are printed with a 100 percent ink coverage. The palette shows the vibrancy of the sport and the fashion of the industry.

Budget $3,000 **Cost** $1,500 (design), $1,500 (printing)

Art Director/Studio Joel Fuller, Lisa Ashworth/Pinkhaus Design Corp.

Designer/Studio Lisa Ashworth/ Pinkhaus Design Corp.

Illustrator Ralf Schuetz

Client/Service Rex Three, Inc., Sunrise, FL/printing and separations

Paper Skytone White Text and Cover 60#

Colors Two, match

Type Matrix (logo), Park Avenue (address), hand-drawn (Rex)

Printing Offset

Concept This client, one of Miami's oldest and most established separation houses, wanted a fresh, new letterhead to replace a stale image.

Special Visual Effect The red, yellow and blue areas are embossed to give the dogs a lifelike three-dimensional quality, and to highlight the "three" in the client's name.

Cost $3,500 (logo and letterhead design)

REX THREE, INC.

REX THREE, INC.
15431 S.W. 14th Street, Sunrise, Florida 33326

NANCY BOULAY

Production
Coordinator

REX THREE
INC. ⟶

Broward
305.452.8301

Dade
305.945.8856

Florida
1.800.545.4370

US
1.800.782.6509

Facsimile
305.452.0569

Designer/Studio Eric Rickabaugh/
Rickabaugh Graphics
Client/Service Rickabaugh Graphics,
Gahanna, OH/graphic design
Paper Strathmore Writing White
Colors Two, match
Type NWX 2000 (client name),
Coryinus Bold (Graphic Design),
Copperplate (remaining copy)
Printing Offset

Concept The studio wanted a letter-
head design that was functional yet
reflected its creativity and sense of
humor. The design was used on
standard components in addition to
a second sheet and two adhesive
labels.
Special Visual Effect The die-cut
business card adds visual interest
and a sense of novelty.
Cost $700 (printing)

**RALSTON
PHOTOGRAPHY**

P.O. Box 7203
Seattle, WA
98133
206-624-9110

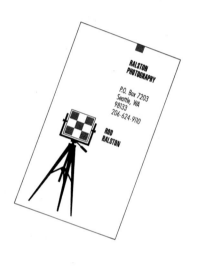

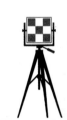

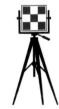

Art Director/Studio Jack Anderson/
Hornall Anderson Design Works
Designer/Studio Jack Anderson,
Cheri Huber/Hornall Anderson
Design Works
Illustrator Cheri Huber
Client/Service Rod Ralston
Photography, Seattle, WA/
photography
Paper Neenah Classic Crest
Colors Two, match
Type Helvetica (client name),
Futura (remaining copy)
Printing Offset

Concept This design solution,
applied to standard components as
well as a mailing label, uses a graph-
ic pun that merges the Ralston
Purina corporate icon with the pho-
tographic icon. The client, just start-
ing his business, was looking for an
approachable identity with "punch."
Cost-saving Technique The same
size image was used on all pieces.

C.A. SINGER & ASSOCIATES, Inc.
Archaeology · Cultural Resources & Lithic Studies

John E. Atwood 805/295-8326
Los Angeles Area Office · fax: 805/257-3056
24307 Magic Mountain Parkway, Suite #61 · Valencia · California 91355

C.A. SINGER & ASSOCIATES, Inc.
Archaeology · Cultural Resources & Lithic Studies

24307 Magic Mountain Parkway, Suite #61 · Valencia · California 91355
phone: 805/295-8326 · fax: 805/257-3056

Designer/Studio Gunnar Swanson/ Gunnar Swanson Design Office
Client/Service C.A. Singer & Associates, Inc., Valencia and Cambria, CA/archaeological surveys
Paper Neenah Classic Crest Millstone
Colors Two, match
Type Frutiger
Printing Offset

Concept The letterhead and logo are meant to evoke California's archaeology. The design is based upon Chumash Indian petroglyphs, including one — the lizardlike figure — discovered by the firm's founder.
Special Visual Effect The palette is similar to those in the original glyphs. The paper stock is reminiscent of stone surfaces.
Special Production Technique This logo design, originally hand-inked, was pulled from a previous letterhead designed by this studio and scanned and rendered on the computer.
Cost $1,350 (design/production, exclusive of logo), $2,900 (output/printing)

The Fit Kids America Aerobic Team, Inc. 631 Ninth Avenue, 3F New York, New York 10036 Telephone 212-247-3573

Designer/Studio Colin Forbes, Donna Ching/Pentagram Design Inc.
Illustrator Donna Ching
Client/Service Fit Kids America Aerobic Team, Inc., New York, NY/not-for-profit children's aerobic team
Paper Strathmore Writing Bright White
Colors Two, match
Type Century
Printing Offset

Concept The objective was to express that the program helped socioeconomically disadvantaged youth achieve as much as possible, both physically and mentally. The logo design projects a positive, young, American feeling without being trendy or too race-, sex- or age-specific.
Budget None **Cost** None (all services were donated)

Art Director/Studio Douglas D. Diedrich/Held & Diedrich Design, Inc.

Designer/Studio Douglas D. Diedrich/Held & Diedrich Design, Inc.

Illustrator Douglas D. Diedrich

Client/Product Dalmatian Fire, Inc., Indianapolis, IN/fire sprinkler design and installation

Paper Beckett Enhance

Colors Two, match

Type Helvetica Extra Condensed (Dalmatian)

Printing Offset, thermography

Concept The dalmatian provided a unique yet identifiable symbol and name for this client, whose industry is one hundred years old.

Special Visual Effect Thermography gives the pieces a strong, tactile feel.

Budget $6,000 **Cost** $4,000 (design), $2,000 (printing)

5624 West 73rd Street
P. O. Box 78068
Indianapolis, Indiana 46278
(317) 299-3889
FAX (317) 299-4078

CINCINNATI INDIANAPOLIS ORLANDO

5624 West 73rd Street
P. O. Box 78068
Indianapolis, Indiana 46278

Richard A. Ackley
President

5624 West 73rd Street
P. O. Box 78068
Indianapolis, Indiana 46278
(317) 299-3889
FAX (317) 299-4078

Designers/Studio Dan Wheaton, Shirley Riordon/The Riordon Design Group Inc.

Illustrator Dan Wheaton

Client/Service Response Data Systems, Mississauga, Ontario/ design of custom accounting software

Paper Neenah Classic Crest Solar White

Colors Seven, match

Type Insignia (Response), Industria (Data Systems), Helvetica Light Condensed (address), Univers Bold & Light (contact names, titles)

Printing Offset

Concept The fingerprint on the computer disk captures the unique nature of this business. The design was applied to mailing and disk labels, as well as standard letterhead pieces.

Special Visual Effect The logo's seven colors give it life against the stark white paper.

Cost-saving Technique An overrun of logo-only business cards was printed so that only the name, title and address have to be printed in two color in the future.

Budget $5,500 **Cost** $5,200 (design/printing)

Art Director/Studio Jack Anderson/
Hornall Anderson Design Works
Designers/Studio Jack Anderson,
Jani Drewfs/Hornall Anderson
Design Works
Illustrator Jani Drewfs
Client/Service The Klinkam
Company, Seattle, WA/construction
management
Paper Strathmore Writing
Colors Two, match
Type Garamond (client name),
Eurostile (remaining copy)
Printing Offset

Concept The logo design is a sym-
bolic interpretation of the various
types of businesses the client
coordinates.
Special Visual Effect The back-
ground graphics, to which a tinted
varnish was applied, pick up on
elements in the logo.

THE KLINKAM
COMPANY

Construction
Management

735 Skinner Building
Fifth Avenue
Seattle, WA
98101
(206) 624-9735

THE KLINKAM
COMPANY

Construction
Management

735 Skinner Building
Fifth Avenue
Seattle, WA
98101

Craig J. Klinkam

Construction
Management

735 Skinner Building
Fifth Avenue
Seattle, WA
98101
(206) 624-9735

THE KLINKAM
COMPANY

Special Production Techniques

Designer/Studio David K. Carroll
Client/Product Clothes 2 Die 4,
Cincinnati, OH/retail clothing
Paper Parchtone White Mottled
Colors Three, match
Type Helvetica (Clothes), Century
Bold Condensed Italic—slightly
altered (all numerals), Matrix
Narrow (remaining copy)
Printing Offset

Concept The cherub illustrates the
client's name, gives "Die" a positive
connotation, and creates strong
name recognition. The design, or
portions of it, was applied to every-
thing from notecards and envelopes
to signage and promotions.
Cost-saving Techniques The back-
ground visual was generated by
photocopying and enlarging the
original logo line art. The logo type
was photocopied to size from a type-
set galley, then cut and positioned
by hand.
Budget $600 **Cost** $600 (design)

Designer/Studio Mark T. Cole/37
Design Group, Inc.
Illustrator Brian E. Lucier
Client/Service Pendleton Printers,
Gardner, MA/printing
Paper Simpson Evergreen Recycled
Hickory
Colors Eight plus varnish, match
Type Helvetica Ultra Compressed
Regular (timeless impressions...),
Helvetica Ultra Compressed Modified
(Pendleton Printers), Avant Garde
(remaining copy)
Printing Offset

Concept The client wanted an
upbeat symbol versatile enough for
use on a wide range of applications,
printed with anything from one to
four or more colors.
Special Visual Effects The logo line
work was designed so some could be
deleted as needed, depending on the
number of colors being printed. A
matte varnish on the entire logo—
graphics and type—brings up the
colors' brilliance, which had been
diminished due to printing on this
stock.
Type "Pendleton" was outlined to
emphasize the client's name and to
sharpen and separate the letters.
Special Production Techniques The
illustration was created in Adobe
Illustrator and nine pieces of film
output through Linotronic.
Budget $5,000 **Cost** $5,000
(design)

Art Director/Studio Tim Gant/
Held & Diedrich Design, Inc.
Designer/Studio Tim Gant/Held
& Diedrich Design, Inc.
Illustrator Tim Gant
Client/Service Holman
Engineering, McCordsville,
IN/automotive engineering devel-
opment
Paper French Paper Speckletone
Chalk White
Colors Two, match
Type Univers 49
Printing Offset, thermography

Concept This client's market is
manufacturers without in-house
design and engineering capabili-
ties. The design illustrates the
client's ability to handle machine
tooling and to produce prototypi-
cal models and machinery.
Special Production Technique The
background drawing was printed
in a flat color; the logo and copy
were thermographically printed.

Art Director/Studio Anita Meyer/plus
design inc.
Designer Anita Meyer
Illustrator Anita Meyer
Client/Service Linda Marino
Catering, Jamaica Plain, MA/cater-
ing
Paper Hopper Tapestry Carrara
White Silk Text 80#
(letterhead/envelope), Hopper
Tapestry Carrara White Silk Cover
80# (business card), Strathmore
Ultra White Label Stock (mailing
label)
Colors Six, match
Type Frutiger
Printing Offset

Concept This system reflects the
client's full range of cuisines and
presentations. The design is applied
to traditional pieces, four 3 1/2 x 3
1/2-inch business cards and a mailing
label.
Special Visual Effects The palette
was based upon food colors and sea-
sonal occasions. The design layout
and the paper stock recall a table
setting on fine linen.
Special Production Techniques Some
business cards were scored and fold-
ed; others were not. Both embossing
and debossing were used to create
the plate impressions.

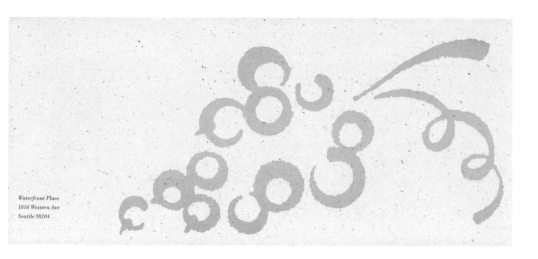

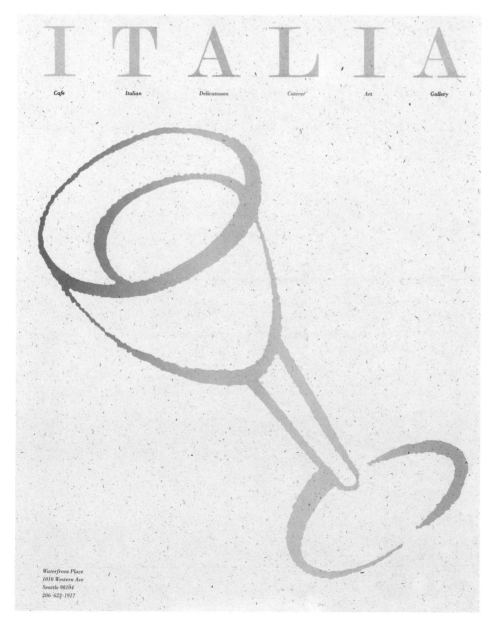

Art Director/Studio Jack Anderson/ Hornall Anderson Design Works
Designers/Studio Jack Anderson, Julia LaPine/Hornall Anderson Design Works
Illustrator Julia LaPine
Client/Service Italia, Seattle, WA/restaurant and delicatessen
Paper French Paper Speckletone
Colors Two, match
Type Modern (client name), Bodoni Italic (remaining copy)
Printing Offset

Concept The sophisticated letterhead design carries through the client's existing logo, which is a cubist-like table setting created by this studio. The studio extracted the main elements and increased their scale for dynamic graphics that add depth to the client's identity and image.
Special Production Technique The use of a split fountain gave the design more color variety and gradation for the cost of one-color printing.

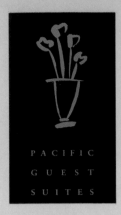

Designer/Studio Julia LaPine/
Hornall Anderson Design Works
Client/Service Pacific Guest Suites,
Bellevue, WA/extended stay accom-
modations
Paper Crane Crest
Colors Three plus foil, match
Type Palatino
Printing Offset

Concept This client wanted to refine
its image with an expensive, classic-
looking system that included a
parking pass, mailing label, compli-
ment card and downsized envelope,
in addition to standard letterhead
pieces. The goals were to stress the
client's belief in quality, to find new
marketing opportunities, and to
gain prominence. The design needed
to incorporate qualities of the hospi-
tality industry: warmth and person-
al attention, but also "high tech—
high touch" conveniences.
Special Visual Effects The logo is
printed in a metallic ink with a clear
varnish applied.
Special Production Technique The
black was double-bumped to give it
density and richness.

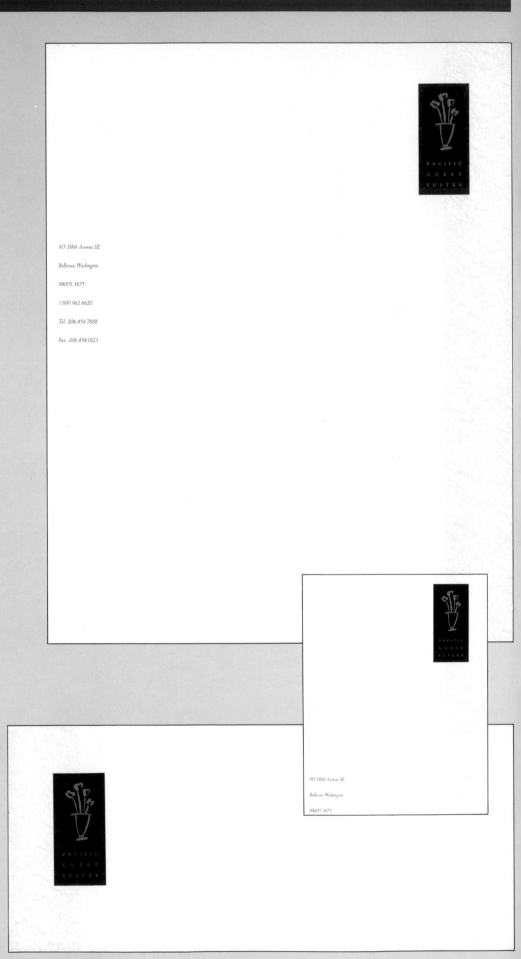

Designer and Illustrator/Studio
Andreé Cordella/
Cordella Design
Line art Sam Petrucci
Client/Service Cordella
Design, Boston, MA/
graphic design
Paper Svecia Antiqua
Chamois (light-colored
stock), Zanders Elephant Hide
(green-tone stock)
Colors One ink plus foil, match
Type Wolf Antiqua (studio name),
Optima (remaining copy)
Printing Offset (type), foil stamping
(logo)

Concept Cordella Design wanted a
system that reflected its tactile,
high-quality and detail-oriented
work. The classic approach
will enable the system to
maintain its freshness. The
design was applied to stan-
dard- and smaller-sized let-
terhead and envelopes; sec-
ond sheets; production,
mailing and return address
labels; a brochure hangtag; a
13 1/4 x 10-inch envelope; a
single-fold business card;
and wrapping paper. The
large, eye-catching envelope
can function as a folder in
which to mail samples. The
hangtag is folded over the
front of sample brochures.
**Special Production
Techniques** A dimensional
die was created for the logo,
which was then gold foil
stamped. The business
cards' employee names were
printed separately and hand-
attached with ribbons.
Budget $47,000 **Cost**
$47,000 (design/printing)

R. BRUCE GRENE, MD
R E F R A C T I V E S U R G E R Y

EYE CLINIC OF WICHITA
655 NORTH WOODLAWN
WICHITA, KANSAS 67208
316/684-5158

R. BRUCE GRENE, MD
R E F R A C T I V E S U R G E R Y

EYE CLINIC OF WICHITA
655 NORTH WOODLAWN
WICHITA, KANSAS 67208

R. BRUCE GRENE, MD

REFRACTIVE SURGERY
CORNEAL TRANSPLANTATION
CATARACT & IMPLANT SURGERY

EYE CLINIC OF WICHITA
655 NORTH WOODLAWN
WICHITA, KANSAS 67208
316 · 684 · 5158

Designers/Studio Bill Gardner, Sonia Greteman, Susan Mikulecky/ Gardner Greteman Mikulecky
Client/Service Dr. R. Bruce Grene, Wichita, KS/ophthalmologist
Paper Neenah Classic Crest Natural White
Colors Three, match
Type Berkeley Old Style Book
Printing Offset

Concept This letterhead had to express "flair" to the client's patients, who are upscale professionals. Marble texture and classic typography rather than a logo became the client's identity.
Special Visual Effect The die-cut eye adds a unique twist. To ensure that it would not be damaged during mailing, the designers test-mailed a mock-up prior to printing.
Special Production Techniques The marble texture was achieved with a halftone and two-color printing rather than more expensive four-color separation.
Budget $3,000 **Cost** $1,500 (design), $1,500 (printing)

Designers/Studio Bill Gardner,
Sonia Greteman, Susan Mikulecky/
Gardner Greteman Mikulecky
Client/Service Dr. R. Bruce Grene,
Wichita, KS/ophthalmologist
Paper Neenah Classic Crest Avon
Brilliant White
Colors Four, match
Type Berkeley Old Style Book
Printing Offset

Concept The letterhead projects the
personality of the client: energetic
and flamboyant. This is his second
system, designed to complement new
offices.

Special Visual Effects The green and
red palette was derived from the
Italian flag—a favorite of the
client—to give the design energy,
impact and a progressive look.

Special Production Technique The
envelope was converted so that
placement of the bars on its lower
edge satisfies postal requirements.
Toyo ink was used in order to exact-
ly match the gold of the letterhead
system to the gold of the new offices.

Budget $5,000 **Cost** $2,000
(design), $3,000 (printing)

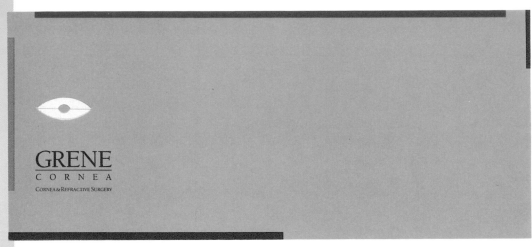

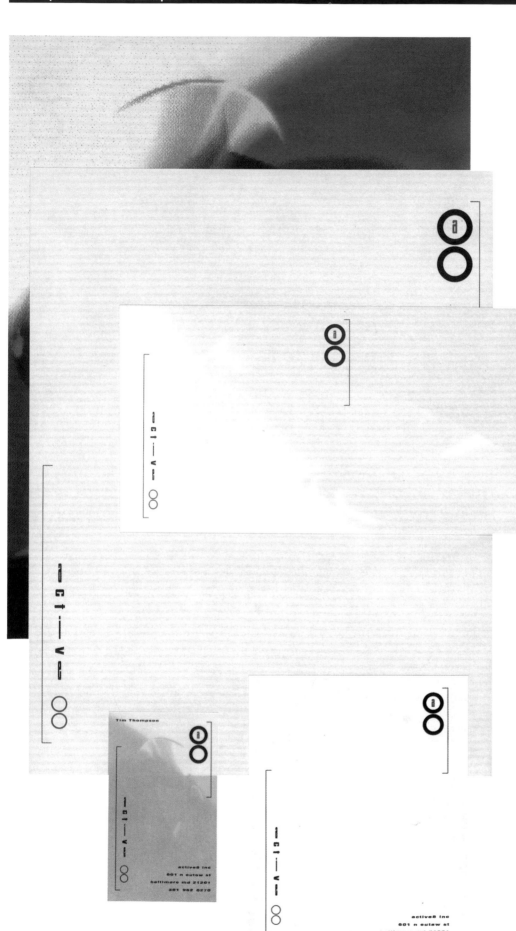

Art Directors/Studio Morton Jackson, Tim Thompson/Graffito
Designer/Studio Morton Jackson/ Graffito
Photographer Morton Jackson
Client/Service Active8, Inc., Baltimore, MD/interactive and multimedia presentations
Paper Curtis Brightwater Writing, Artesian White, Gilclear 70#
Colors Four, process
Type Helvetica Bold Condensed— computer manipulated for logo and text
Printing Offset

Concept The challenge was to design an interactive letterhead solution. The system added a mailing label to the standard letterhead components.

Special Visual Effect The designer's solution was to print on both sides of translucent paper so the sides interacted with each other.

Special Production Technique The same four-color image of a laser disc was printed on the back of the letterhead and the business card and on the inside of the envelope. During printing, magenta was replaced with Rubine Red.

Budget $20,000 **Cost** $17,800 (design/printing)

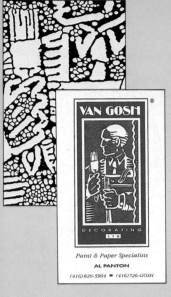

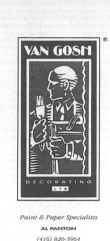

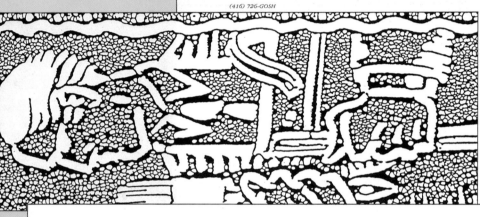

Designer/Studio Ric Riordon/The Riordon Design Group Inc.
Client/Services Van Gosh Decorating Ltd., Mississauga, Ontario/painting and wallpapering of corporate interiors
Paper Curtis Brightwater Cover Natural White Riblaid Finish 80#
Colors Three, match

Type Letraset Binner (Van Gosh), Avant Garde (Decorating LTD), Garamond Italic (client's service and telephone), Futura Bold (contact name)
Printing Offset

Concept The logo illustration portrays the client in corporate attire with brush and wallpaper book in hand. The client insisted that the Binner typeface from his previous letterhead system be incorporated. The design is applied to standard letterhead pieces plus an invoice form.
Special Visual Effect The bold and modern color palette reflects the client's personality.
Special Production Technique The background texture uses a special pastel purple ink mix; a screen of the purple was unable to make a consistently toned background while keeping a solid purple.
Budget $4,500 **Cost** $4,500 (design/printing)

Designer/Studio Stan Spooner/ McMonigle & Spooner

Client/Service Type Gallery Printers, Walnut, CA/full-service print broker

Paper James River Tuscan Terra-Fresco Text

Colors Four over two, match

Type Hand-lettering (Type), Futura Black and Futura (remaining copy)

Printing Offset

Concept This client's letterhead needed to be a showpiece for its printing capabilities.

Special Visual Effects An enlarged abstraction of the logo is printed on back of the letterhead and business card and inside the envelope, creating a subtle screened effect.

Special Production Techniques The logo area surrounding "Type" and "Gallery" is embossed, as is the word "Printers." The reverse-side pattern is printed in 50 percent black over a screen of a second match color.

Cost-saving Technique To avoid custom-making envelopes, the designer printed the scallop effect on stock envelopes in reverse of the letterhead's scallop.

Budget $4,000 **Cost** None (design was traded)

Designers/Studio Bill Gardner, Sonia Greteman, Susan Mikulecky/ Gardner Greteman Mikulecky
Client/Service Equity Standard Numismatics of Kansas, Wichita, KS/rare coin brokerage
Paper Crosspoint Passport
Colors Two, match
Type Custom face (logo), Garamond Condensed (remaining copy)
Printing Offset

Concept An icon in the background resembles a seal of authenticity. The logo is composed of elements used in coinage.
Cost-saving Technique Printing the background icon as a 5 percent screen of the gold metallic ink eliminated the need for a third color. The use of dry traps (letting the flat ink dry before laying down the metallic) saved having to put down several hits of the flat color, which is often necessary when butt-fitting flat and metallic inks.
Budget $3,000 **Cost** $1,500 (design), $1,500 (printing)

Designers/Studio Ronald Jacomini, Tony Duda/Jacomini & Duda, Ltd.

Client/Service Jacomini & Duda, Ltd., Bowling Green, OH/design and illustration

Paper French Paper Speckletone Briquet

Colors One, process

Type Onyx (initial caps), Spire (remainder of names following initial caps), Title Gothic Condensed (reversed initial caps and address on rubber stamps), Empire (remainder of names following reversed initial caps and studio name on rubber stamps); all type slightly altered

Printing Offset

Concept Original, hand-colored stamps create a one-of-a-kind look and show this studio's commitment to quality and personal service.

Special Visual Effects The design utilizes airbrushed gummed stamps, rubber stamps and thermographically printed type. The folded business cards contain two hand-colored stamps in a "collector's" envelope. The stamp illustrations were collected mostly from old magazines, photocopied at various sizes, then altered to facilitate coloring. The type was original to the illustrations.

Special Production Techniques The roughness of thermographic printing was produced by pressing a rubber stamp repeatedly on a paper napkin, then photocopying the final impression.

Cost $1,000 (design/printing)

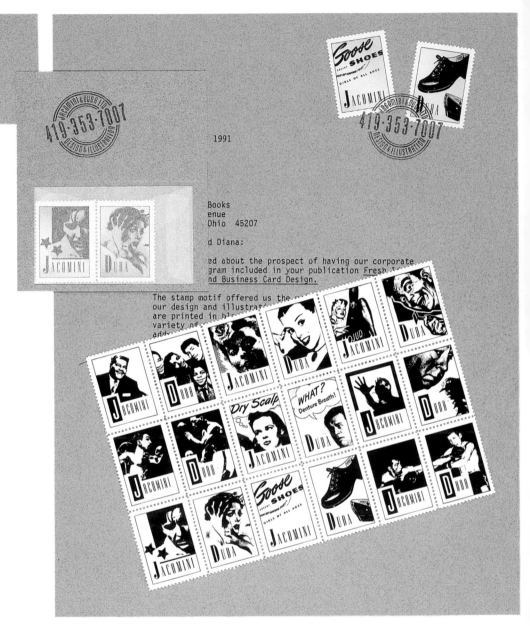

The American Institute of Architects, *Cleveland Chapter* 410 The Arcade, Cleveland Ohio 44114, Phone 216 771-1240

1990 EXECUTIVE BOARD

President Keith E. White, A I A	*Secretary* William T. Wells, A I A	*ASO Director* G. Robert McCullough, A I A	*Director* Robert C. Ahrens, A I A
Vice President/President Elect James D. Gibans, A I A	*Treasurer* Raymond G. Kramer, A I A	*ASO Alternate Director* Robert A. Fiala, A I A	*Immediate Past President* Todd Schmidt, A I A
	Director Dominick Durante, Jr., A I A	*Associate Member Director* Jeanne Weber	*Executive Director* Dianne Hart

The American Institute of Architects, *Cleveland Chapter* 410 The Arcade, Cleveland Ohio 44114, Phone 216 771-1240

1890 CENTENNIAL ANNIVERSARY 1990

Designer/Studio Okey Nestor/ Nesnadny & Schwartz

Client/Service American Institute of Architects, Cleveland, OH/ professional trade organization

Paper Simpson Starwhite Vicksburg Vellum Finish Text 70#

Colors Three, match

Type New Baskerville Regular and Italic

Printing Offset

Concept The client wanted an image that appeared organized, professional and creative; had an individual personality; and recognized its national association.

Special Visual Effects Inclusion of the executive board membership list inspired the designer to add the top flap—which also serves as a closure device—as a way of drawing attention to the names. The palette of historic architectural colors symbolize both the organization's centennial anniversary and Cleveland's own historic architecture.

Designers/Studio Jamie McMonigle, Stan Spooner/McMonigle & Spooner

Client/Product Gateway Educational Products, Ltd., Orange, CA/audio educational products

Paper James River Tuscan Terra-Flax Text

Colors Four, process

Type Americana (logo), Garamond Book Condensed (remaining copy)

Printing Offset

Concept The client wanted a tasteful image that had impact.

Special Visual Effects The background texture is a takeoff of the client's well-known 1-800-ABCDEFG telephone number.

Special Production Technique Three-dimensional embossing gives extreme depth to the globe.

Cost-saving Technique A computer-generated 2 percent black screen provides light background texture without the cost of a fifth color.

Budget $10,000 **Cost** $2,800 (design/printing, exclusive of logo design)

Gateway Educational Products, Ltd.
1050 West Katella Avenue, Suite D
Orange, California 92667
714-633-2223

Gateway Educational Products, Ltd.
1045 W. Katella Avenue, Suite 200
Orange, California 92667
714-633-2223

Jane Wages M.A.
Editor-in-Chief/Writer

Gateway Educational Products, Ltd.
1050 West Katella Avenue, Suite D
Orange, California 92667

M A N L O V E P H O T O G R A P H Y

M A N L O V E P H O T O G R A P H Y

16 HOBNER COURT
WILMINGTON,
DELAWARE 19808

302 ● 998 ● 9624

JOE MANLOVE

16 HOBNER COURT ● WILMINGTON, DELAWARE 19808

M A N L O V E P H O T O G R A P H Y

16 HOBNER COURT
WILMINGTON,
DELAWARE 19808

3 0 2 ● 9 9 8 ● 9 6 2 4

Designer/Studio Tony Ross/Ross Design Inc.
Illustrator John Francis
Client/Service Joe Manlove, Wilmington, DE/photography
Paper Kimberly Writing
Colors Two, match
Type Futura
Printing Offset

Concept The intent was to subtly show light and color, the two most important elements in photography. This clean, simple solution is suitable for a photographer who wanted to attract attention in a highly competitive field.
Special Visual Effect The filmlike die-cut edge immediately says photography. Different colors on the letterhead components portray the importance of color in photography.
Cost-saving Technique Three-color printing was done more economically by printing each color on different presses.
Cost $1,384 (printing)

Designer/Studio John Sayles/Sayles Graphic Design

Client/Service Advertising Professionals of Des Moines, Des Moines, IA/trade association

Paper James River Tuscan Terra Pebble

Colors Two, match

Type Palatino Italic Condensed

Printing Offset

Concept This 75-year-old advertising club needed a new, professional image, logo and letterhead system. The corporate-looking colors convey stability while the innovative design communicates creativity. The solution was applied to a self-mailing notecard, as well as stationery and envelopes.

Special Visual Effects The three loops in the logo are "P"s that, when connected, form an "A." The teardrop shape formed by the loops is repeated in three spots, almost as if it was punched out of the logo. The background textures are enlarged portions of the logo.

Special Production Technique The pieces are inked nearly 100 percent; the light-toned areas are the paper color.

Designer/Studio Phylane Norman,
Tod German/Condon Norman
Design
Client/Service Patricia Locke,
Mundelein, IL/design and manufac-
ture of semiprecious jewelry
Paper French Paper Speckletone
Ivory
Colors One, match
Type Goudy Bold (client name),
Goudy Italic (remaining copy)
Printing Offset, engraving

Concept This system mirrors the
simple and classic elegance of the
client's jewelry. The design is
applied to the traditional letterhead
pieces, in addition to a hangtag/jew-
elry card, gift card and
notecard/announcement.
Special Production Technique One-
third of the notecard/announcement
is folded over, and information can
be printed inside the flap as needed.
The card is mailable with or without
an envelope.
Cost-saving Technique Engraving
costs were lowered by creating sev-
eral multipurpose components.
Printing costs were lowered by the
use of one color.
Budget $4,500 **Cost** $3,500
(design/printing)

Designer/Studio Douglas D. Diedrich/Held & Diedrich Design, Inc.
Client/Service Dr. Timothy L. Bray, Monrovia, IN/general dentistry
Paper Gilbert Oxford
Colors One, match
Type Unknown
Printing Offset

Concept Because dentists are still leery of marketing themselves, the designer felt a letterhead system might be the client's most important marketing tool. The client's ultimate goal was that the system be fun—even humorous, to put patients at ease—yet conservative.
Special Visual Effect The designer embossed the teeth to make them more realistic. The pink simulates the color of gums. The folded business card and stationery present upper and lower dental impressions.
Special Production Technique The business card and stationery are four fold.
Budget $5,000-6,000 **Cost** $3,500 (design), $2,500 (printing)

DR.TIMOTHY L. BRAY

DR.TIMOTHY L. BRAY

DR.TIMOTHY L. BRAY

FAMILY DENTISTRY

FAMILY DENTISTRY

Dr. Timothy L. Bray
(317) 996-3391

metic Dentistry
nts Welcome
ening Service
Visa Accepted

39 · Monrovia, IN 46157

FAMILY DENTISTRY

3097 South State Rd. 39 · Monrovia, IN 46157 · (317) 996-3391
Family & Cosmetic Dentistry

DR.TIMOTHY L. BRAY

FAMILY DENTISTRY

JIM LASER
PHOTOGRAPHER

JIM LASER
PHOTOGRAPHER

THE LASER WORKS
ATELIER PHOTOGRAPHIQUE

WILDWOOD BEACH·HANSVILLE·WASHINGTON 98340
206 638 - 2131

THE LASER WORKS
ATELIER PHOTOGRAPHIQUE

WILDWOOD BEACH·HANSVILLE·WASHINGTON 98340
206 638 - 2131

Designers/Studio Jack Anderson, Raymond Terada/Hornall Anderson Design Works

Client/Service Jim Laser, Hansville, WA/photography

Paper Crane Crest

Colors Six, match

Type Goudy

Printing Offset

Concept The client's subject matter focuses on both architecture and macrophotography of flowers. The objective was to present the client as a fine artist rather than a commercial photographer. The solution was applied to a mailing label in addition to standard letterhead pieces.

Special Visual Effects The pastel coloring of the client's floral photography influenced the color palette. The beveled look demonstrates his architectural sensitivity. The border design represents film border.

Special Production Technique The client's name was embossed to add shadow and increase legibility.

Designer/Studio Gunnar Swanson/ Gunnar Swanson Design Office
Client/Service Image Works West, Los Angeles, CA/location photography
Paper Crane Kid Finish 32# (letterhead), Crane Parchment Distant White 67#
Colors Two, match
Type Goudy Oldstyle
Printing Engraving

Concept The goal was to communicate elegance and classicism. The logo is an adaptation of an existing trademark. Its treatment on the second sheet adds an interesting twist.
Special Production Techniques The gray type and the warm red rules on the logo were engraved. The square of the logo was blind embossed.
Cost-saving Technique One of the dies was sized to work on the letterhead's first and second sheets and on the envelope. The colors were bumped.
Cost $2,000 (design/production), $1,378 (printing)

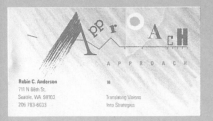

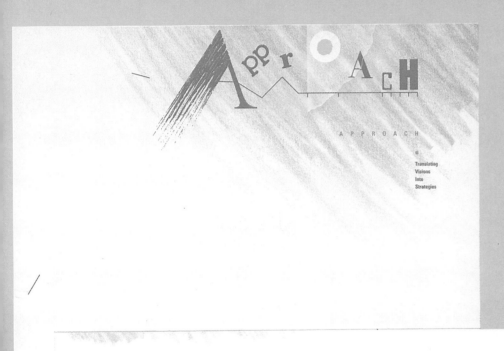

Designers/Studio Jack Anderson, Juliet Shen/Hornall Anderson Design Works

Client/Service Approach, Seattle, WA/project management consultation

Paper Simpson Protocol

Colors Two, match

Type Custom lettering (logo), Univers (remaining copy)

Printing Offset

Concept The client is a consultant who organizes events and information with a creative style. The logo depicts the progression from chaos to organization.

Special Visual Effects The gray halftone is a photograph of a three-dimensional piece of art. The "o" is knocked out and drilled. Green was chosen because of its warm, non-trendy qualities and because it suggests success.

Cost-saving Technique The hole was drilled using a standard bit size rather than a die.

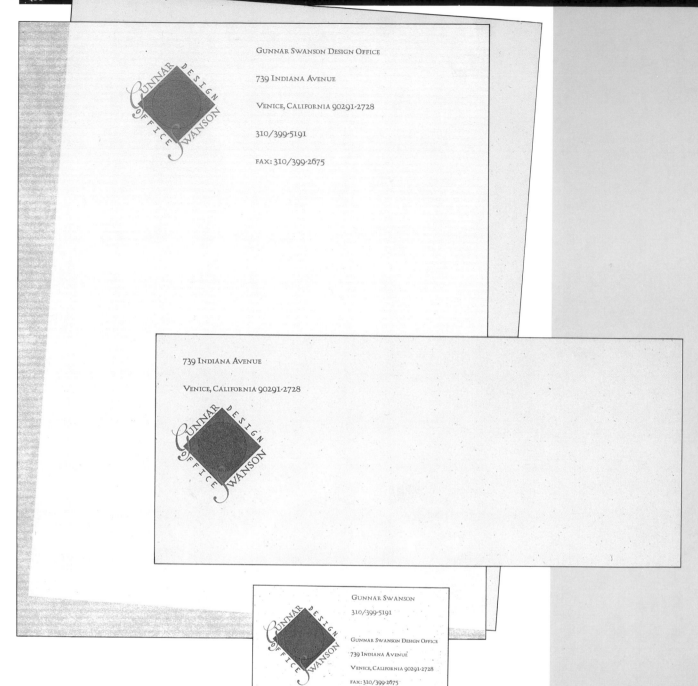

Designer/Studio Gunnar Swanson/
Gunnar Swanson Design Office
Client/Service Gunnar Swanson
Design Office, Venice, CA/graphic
design and marketing consultation
Paper Curtis Parchkin Riblaid (let-
terhead), Simpson Evergreen Text
Hickory (envelope and second
sheet), Riegel PCW Cover (business
card)
Colors Three, match
Type Snell Roundhand (logo, G and
S), Hadriano (logo, remaining letters

and address), OCRA (Design Office)
Printing Offset

Concept This marketing-oriented
designer wanted a letterhead that
was distinctive but not trendy, left of
center yet classic, and unique with-
out being cute or weird.
Special Production Technique White
ink was printed on the backs of the
letterhead and business card and on
the envelope similar to a watermark.
The center circle of the logo was

printed with a screen of the bronze
metallic over the green.
Special Visual Effect Three different
stocks give the system an added
dimension.
Budget None **Cost** None (design
service was traded for printing)

HAMPTON PRESS PUBLISHING COMPANY □ 507 BOTETOURT STREET □ NORFOLK, VIRGINIA 23510 □ 804-625-1253

MONICA NICHOLSON, RN
Director of Workshops

HAMPTON PRESS PUBLISHING COMPANY
507 BOTETOURT STREET
NORFOLK, VIRGINIA 23510
804-625-1253

Designer/Studio Lynn Harrisberger/
Harrisberger Creative
Illustrator Claire Lingenfelser
Client/Product Hampton Press
Publishing Company, Norfolk,
VA/medical text books
Paper Gilbert Oxford
Colors Two plus foil, match
Type Goudy
Printing Offset

Concept The Williamsburg look
portrays the client as an old, well-
established publisher. A nonexplicit
logo was designed to avoid depicting
the books themselves, many of
which show graphic visuals of
reconstructive surgery.
Special Production Technique The
design features multilevel sculptured
embossing with pearlized foil
stamping.
Cost $9,000 (design/printing)

Art Director/Studio Richard Foy/
Communication Arts Incorporated
Designer/Studio Hugh Enockson/
Communication Arts Incorporated
Client/Service Astarte, Inc., Boulder,
CO/venture capital firm, sugar cane
processor
Paper Simpson Starwhite
Vicksburg Archiva
Colors Two, match
Type Berling Antiqua (logo),
Garamond No. 3 (remaining copy)
Printing Offset, engraving

Concept The client required a
sophisticated, elegant symbol or pic-
togram for Sugartree, a subsidiary
of Astarte. The design had to func-
tion independently as well as fit
within a collective package of sub-
sidiaries, including software,
telecommunications and manufac-
turing.
Special Production Technique All
typography is gold engraved.
Cost-saving Technique The same
size engraving die was used for the
logotype on all pieces.
Budget $1,500 **Cost** $2,800
(design/printing)

SUGARTREE

1035 PEARL STREET 5TH FLOOR BOULDER COLORADO USA 80302 303 447 3068 FAX 303 449 2773

SUGARTREE

SUGARTREE

WILLIAM H. PEARLMAN
Executive Vice President

1035 PEARL STREET 5TH FLOOR
BOULDER COLORADO USA 80502
303 447 3068 FAX 303 449 2773

PINKHAUS

PINKHAUS

JOEL
FULLER

2424
S. DIXIE HIGHWAY
SUITE 201
MIAMI FLORIDA
33133

USA

PINKHAUS

2424
S. DIXIE HIGHWAY
SUITE 201
MIAMI FLORIDA
33133

Art Director/Studio Joel Fuller/
Pinkhaus Design Corp.
Designers/Studio Tom Sterling,
Mark Cantor, Joel Fuller
Client/Service Pinkhaus Design
Corp., Miami, FL/graphic design
and advertising
Paper ESSE by Gilbert, White,
Texture Writing (letterhead and
envelope); ESSE by Gilbert, White,
Texture, Cover (business card)
Colors Process black, two match,
plus tinted varnish
Type Helvetica manipulated (logo);
Industria (remaining type)
Printing Offset

Concept On April 1, 1992,
Pinkhaus Design Corp. celebrated
the completion of their seventh year
in business. They redesigned their
stationery because it no longer
reflected where they were or where
they wanted to go. This new design
was influenced by many factors,
especially their work environment,
which provided an important state-
ment of Pinkhaus's design philoso-
phy. The use of many different but
compatible materials in their office
—polished concrete, varnished wood
chips, aluminum grating—is much
like the graphic design process,
where many different pieces of
information combine to solve design
problems. Since Pinkhaus was so
involved in designing the ESSE line
of paper for Gilbert, it was the per-
fect choice for their new direction.
(It also prints great.) Because the
paper is recycled, it also reflects
their concern for the environment.
Special Production Techniques The
front (texture side) of the letterhead,
envelopes and business cards was
printed with a tinted varnish, one
impression of a 200 line-screen
black halftone with a match yellow,
match beige and spot matte varnish.
The back of the business cards and
letterheads (smooth side) was print-
ed with a tinted varnish with two
impressions of a 200 line-screen
black halftone and a match yellow
on a six-color press.

Permissions

List of Clients

Abell Pearson Printing Company, 56
Active8, Inc., 116
Advertising Professionals of Des Moines, 124
Alexander, Jonathan and Mary, 82
Amador Land & Cattle, 57
American Institute of Architects, 121
Andy Katz Photography, 71
Approach, 129
Astarte, Inc., 132
Atlanta Artists, 78
Bellegrove Medical Supplies, 58
Bob Gross International Travel, 28
Boston City Hospital Pediatrics, 87
Bray, Dr. Timothy L., 126
Bright Lights, 98
Buena Vista College, 88
C.A. Singer & Associates, Inc., 103
Carlson/Ferrin Architects, 92
Carroll Morgan Photography, 80
Chamberlin & Devore, 16
Chicago Dog & Deli, 85
Chuck Selvaggio, 78
Clothes 2 Die 4, 110
Cohen, Dr. Justin, 84
Coke Farm, 22
Cordella Design, 113
Cornerstone Financial Group, 64
Cossman, Elaine, 73
Cunfer, Elaine, 36
Dalmation Fire, Inc., 105
Danny Rodriguez Music, 45
David Butler Illustration, 18
de la hoz, Mike, 14
Detter Graphic Design, 43
Diftler Design, 14
Dilley Illustration & Design, 42
Earth Flower Art, 19
Emigre Graphics, 63
Equity Standard Numismatics of Kansas, 119
Eymer Design, 29
Fassino/Design, 20
Fit Kids America Aerobic Team, Inc., 104
Galleria Fair, 97
Garuda Mountaineering, 17
Gateway Educational Products, Ltd., 122
Glassworks, 52
Goodman, John F., 40
Grene, Dr. R. Bruce, 114, 115
Gunnar Swanson Design Office, 130
Hampton Press Publishing Company, 131
Hardesty, Debra S., 44
Harrisberger Creative, 38
Heart Thoughts, 50
Holman Engineering, 110
Huber, Carolle M., ASLA, 21
Image Works West, 128
Inn at Langley, The, 79
Integrus Architecture, 95
Interiors by Design, 94
International Sports Development Programs, Inc., 69
Italia Restaurant, 111
Jacomini & Duda, 120
Jake Allen Center for Deaf-Blind Children, The, 83
James Bradley Group, 61
Kapcom, 96
Klinkam Company, The, 107
Krawczyk Design, Inc., 26
Laser, Jim, 127
Leslie Barton Photographer, 34
Libby Carton Design, 54
Linda Marino Catering, 110
Locke, Patricia, 125
M&M Chartered Accountants, 68
McFarland & McFarland, 31
McMonigle & Spooner, 55
Manlove, Joe, 123
Mithun Partners, 74
Mount Vernon Ladies' Association, 35
Mulrooney, Rick, 72
New Yorker magazine, The, 25
Ocean States, 93
Outside In, The, 51
Pacific Guest Suites, 112
Pease Design, Inc., 23
Pendleton Printers, 110
Pinkhaus Design Corp., 133
Polo Club, The, 91
PoorSports, 89
Radio Vision International, 81
Rebholz Photographers, 15
Red Cap Building Services, Inc., 59
Register Printing Company, 33
Rehabilitation Living Centers, Inc., 90
Response Data Systems, 106
Rex Three, Inc., 100
Rickabaugh Graphics, 101
Riordon Design Group, Inc., The, 78
Robin Reichner, Franklin, 32
Rod Ralston Photography, 102
Sandesign Homes, 65
Sayles Graphic Design, 67
Schaffer's Bridal and Formal Shop, 27
Sea Frontiers magazine, 39
Selvaggio, Chuck, 78
17th St. Design Studios, 41
Smashbox, 70
South Schwartz, 30
Steelhaus Design, 75
Suzanne Craig Represents, 49
Team Design, 48
Temel West, 24
Toronto Sun Publications, 86
Tulip Films, Inc., 53
Type Gallery Printers, 118
Van Gosh Decorating Ltd., 117
Villarreal, Martin, 37
Vinifera Imports, 60
Weston Farm, 62
Wichita Team Tennis, 99
Willingtown Construction, 66
Zohra Spa & Clinique, 78

Index

A

Airbrush, 92

Albert Juárez Design & Illustrations, 45

Another Graphic Design Group, 22, 28

B

Bleed, 93
 defined, 10

Brush technique, hand-lettering with, 52

Business cards, 9

C

Carroll, David K., 110

Chermayeff & Geismar Inc., 53

Clip art, 29, 40
 See also Visuals, scanned

Collaboration, client/designer, 7

Color, varying, 16, 30

Colors, selection of, 8

Communication Arts Incorporated, 57, 71, 132

Concept, developing, 7

Condon Norman Design, 125

Cordella Design, 113

Crowder Design, 62

Cunfer, Elaine, 36

D

Debossing, defined, 10

De La Hoz, D'Ann Rose, 14

Design brief, questions for, 7

Detter Graphic Design, Inc., 43

Die cut, 33, 61, 101, 114, 123
 defined, 10
 drilling instead of, 129

Díftler Design, 14, 39

Dilley Illustration & Design, 42

Double bump, 41, 112
 defined, 10

Dry trap, 119
 defined, 10

E

Ellen Cohen Design, 40

Ellen Ziegler Design, 79

Embossing, 60, 100, 118, 122, 126, 127, 131
 blind, 128

defined, 10

Emigre Graphics, 8, 63

Engraving, 57, 71, 125, 128, 132
 defined, 10

Envelope conversion, 6, 71, 89, 115
 defined, 10

Envelopes, stock, 6

Eymer Design, 29, 31

F

Fassino/Design, 20

Foil stamping, 45, 55, 60, 64, 65, 67, 70, 113, 131
 defined, 10

Font, custom-designed, 61, 75
 See also Letterforms, custom-designed

Frund, Kathryn, 16

G

Gang-printing, 94

Gantdesign, 64

Gardner Greteman Mikulecky, 49, 50, 56, 84, 89, 97, 99, 114, 115, 119

Ghosted effect, 50, 96
 defined, 10-11

Graffito, 96, 116

Gunnar Swanson Design Office, 103, 128, 130

H

Halftone, 114, 129, 133
 defined, 11

Hand-assembling, 113

Hand-coloring, 19, 120
 defined, 11

Hand-drawn type, 48, 58, 72

Hand-lettering, 22, 27, 42, 53, 60, 67, 98
 with brush technique, 52

Hardesty, Debra S., 44

Harrisberger Creative, 32, 38, 131

Held & Diedrich Design, Inc., 105, 110, 126

Hennessey, Glenn A., 35

Hornall Anderson Design Works, 52, 60, 74, 92, 95, 102, 107, 111, 112, 127, 129

I

Illustration, and type, 36

Invoice. See Letterhead components, unusual, 23

J

Jacomini & Duda, Ltd., 120

K

Krawczyk Design, Inc., 26

L

Letterforms, custom-designed, 70

Letterhead components, unusual, 16, 23, 29, 32, 42, 44, 53, 62, 63, 67, 70, 73, 74, 75, 78, 81, 92, 95, 96, 98, 101, 102, 106, 112, 113, 116, 117, 124, 125, 127

Letterhead system
 designing low-budget, 9
 elements of design in, 7-8
 make-up of, 6-7

Letterpress, 61, 70, 73

Line drawings, 40
 defined, 11

Linoleum block, rendering in, 79

Logos, 7-8
 foil-stamped, 45, 55
 hand-lettering of, 67
 varying, 16

M

Magnesium die, 65

Mailing label. See Letterhead components, unusual

Margo Chase Design, 61, 70, 73, 81

McMonigle & Spooner, 55, 69, 93, 94, 118, 122

McQuien Matz, 80, 83, 86

Metallic ink, 42, 56, 112, 130
 defined, 11
 screen of, 119

N

Nesnadny & Schwartz, 51, 121

O

Offset printing, defined, 11

See also Thermography, and offset printing

P

Paper
 recycled, 43, 133
 selection of, 8
 transluscent, 116
 using junk stock, 42
 varying stocks of, 130

Pease Design, Inc., 23

Pentagram Design Inc., 54, 82, 98, 104

Pinkhaus Design Corp., 78, 100, 133

Planet Design Company, 15, 34

plus design inc., 110

Press type, 14

Printing techniques, 10-11

Real Image, Inc., The, 37

Rickabaugh Graphics, 101

Riordon Design Group Inc., The, 65, 68, 78, 106, 117

River City Studio, 18

Robin Shepherd Studios, 19

Ross Design Inc., 66, 72, 78, 91, 123

Rub-off process, 68

Rubber stamps, 29, 54, 120
 as illustration technique, defined, 11

Runnion Design, 59, 87

S

Sayles Graphic Design, 27, 67, 85, 88, 124

Scanned art. See Visuals, scanned

Screen tint, 15, 17, 19, 26, 34, 35, 42, 49, 60, 118, 122, 130
 defined, 11
 of metallic ink, 119
 to simulate watermark, 35, 88

17th St. Design Studios, 33, 41

Shooting Star Graphics, 21

Split fountain, 111
 defined, 11

Steelhaus Design, 75

Stock. See Paper

Studio D, Inc., 14

Studio Seireeni, 30

T

Team Design, 48, 58

Ted Mader & Associates, 17

Temel West, 24, 25

Thermography, 14, 120
 defined, 11
 gold, 50
 and offset printing, 66, 69, 105, 110

37 Design Group, Inc., 110

Trade-offs, 9

Type
 computer-manipulated, 116
 custom-designed, 63
 and illustration, 36
 hand-drawn, 48, 58, 72
 selection of, 8
 unusual placement of, 24
 See also Font; Letterforms, custom-designed

V

Varnish
 clear, 112
 defined, 11
 gloss, 61
 matte, 110
 tinted, 50, 90, 107, 133

Vignetting, 80

Visuals, scanned, 17, 29, 103

W

Watermark, simulating, 130
 with screen, 35, 88

Winner Koenig & Associates, 90